ACRYLICS
IN ACTION!

24 Painting Techniques
TO TRY TODAY

ACRYLICS
IN ACTION!

24 Painting Techniques
TO TRY TODAY

C&T PUBLISHING
Another Maker Inspired!

METRIC CONVERSIONS

The metric equivalents are often rounded off for ease of use. If you need more exact measurements, there are a number of amazing online converters.

Acrylics in Action!

First published in the United States in 2023 by C&T Publishing, Inc., P.O. Box 1456, Lafayette, CA 94549

The original German edition was published as Let's Acryl!

Copyright © 2023 frechverlag GmbH, Stuttgart, Germany (www.topp-kreativ.de)

This edition is published by agreement with Anja Endemann, ae Rights Agency, Berlin, Germany

PUBLISHER: Amy Barrett-Daffin

CREATIVE DIRECTOR: Gailen Runge

SENIOR EDITOR: Roxane Cerda

ENGLISH LANGUAGE COVER DESIGNER AND LAYOUT ARTIST: April Mostek

ENGLISH TRANSLATION: Krista Hold

PRODUCTION COORDINATOR: Zinnia Heinzmann

CONCEPT AND PRODUCT MANAGEMENT: Hannelore Irmer-Romeo

EDITOR: Gabriele Betz, Tübingen

COVER DESIGN: Eva Grimme

LAYOUT: Werbeagentur Rypka GmbH, www.rypka.at

MOTIFS: Gabriele Malberg (pp. 122–135), Sylwia Mesch (pp. 10–85 and 136–143), Monika Reiter (pp. 108–119), Christin Stapff (pp. 88–97), Martin Thomas/Sylvia Homberg (pp. 98–107)

Attention Teachers: C&T Publishing, Inc., encourages the use of our books as texts for teaching. You can find lesson plans for many of our titles at ctpub.com or contact us at ctinfo@ctpub.com.

We take great care to ensure that the information included in our products is accurate and presented in good faith, but no warranty is provided, nor are results guaranteed. Having no control over the choices of materials or procedures used, neither the author nor C&T Publishing, Inc., shall have any liability to any person or entity with respect to any loss or damage caused directly or indirectly by the information contained in this book. For your convenience, we post an up-to-date listing of corrections on our website (ctpub.com). If a correction is not already noted, please contact our customer service department at ctinfo@ctpub.com or P.O. Box 1456, Lafayette, CA 94549.

Trademark (™) and registered trademark (®) names are used throughout this book. Rather than use the symbols with every occurrence of a trademark or registered trademark name, we are using the names only in the editorial fashion and to the benefit of the owner, with no intention of infringement.

ISBN: 978-1-64403-283-1

Printed in China

10 9 8 7 6 5 4 3 2 1

CONTENTS

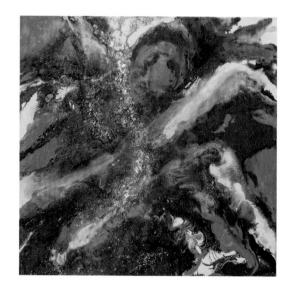

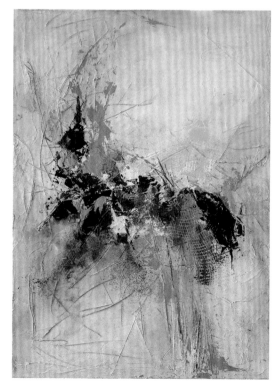

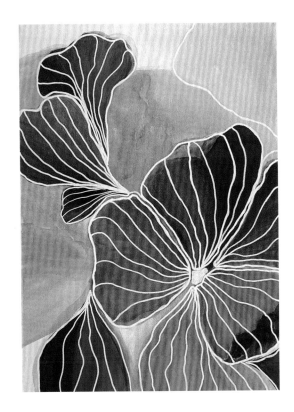

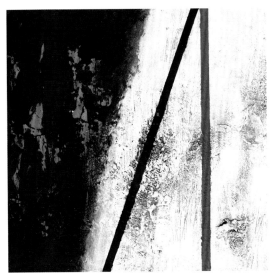

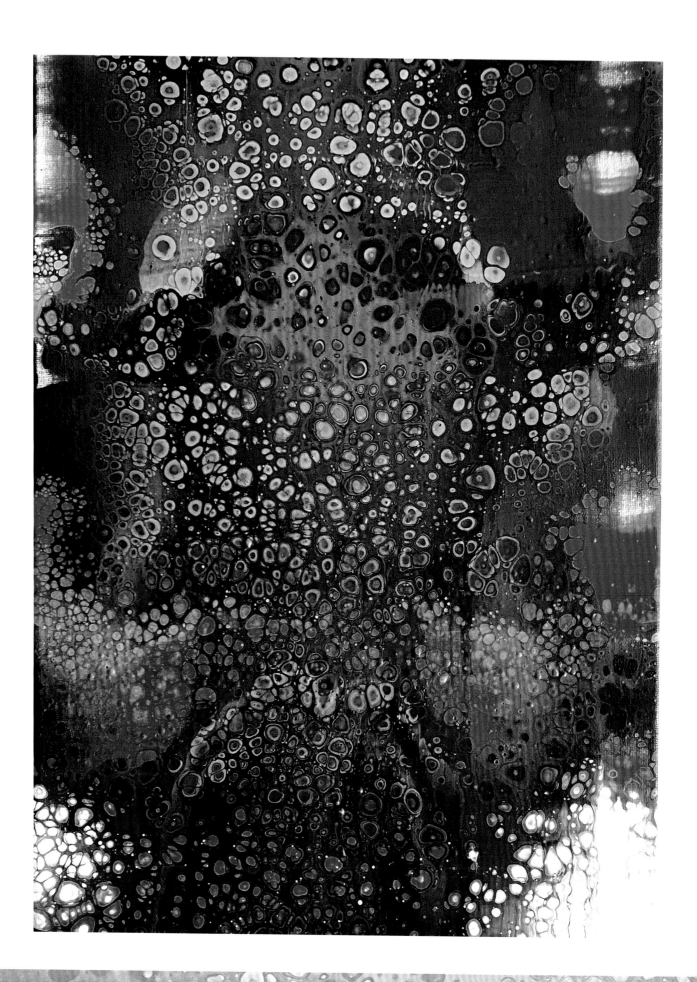

FOREWORD

This book is for every painting enthusiast seeking the inspiration and challenge of a wide variety of acrylic painting techniques.

Modern acrylic paint is easy to handle and makes all painting styles possible: from classic glazing techniques to integrating a texture medium as well as experimenting with the use of ash, casting resin, or even shaving foam.

In the first section of this book you'll discover everything about paint, brushes, and other painting mediums and materials. Using this knowledge, you can put together some basic equipment and gather useful tips. The book also covers mixing techniques and other effects that can be used successfully in acrylic painting.

After that, get ready to be thrown into a world of color. Do you like to combine different techniques? Do you enjoy contrasts? Is experimenting your thing? You'll surely find what you're looking for among the image ideas and designs within the second section. The detailed step-by-step instructions demonstrate how to proceed, but can be modified at any point. After completing the initial exercises, you'll often develop your own ideas for how to implement the exciting patterns, crackle effects, or painting techniques that best match your creative vision.

Have fun looking, learning, painting, and experimenting!

Sylvia Mesch S. Homberg Christin

H. Thomas Monika Reiter

MATERIALS

ACRYLIC PAINT

Acrylic paints are among the most popular painting mediums and their exceptional properties make them versatile and easy to apply. They are water-soluble, but only become waterproof after drying. Even without pre-treatment, they adhere to any grease-free surface. They are almost odorless, solvent-free, have a high vibrancy, are opaque, and can be painted over repeatedly. You can apply them in any consistency you want, and they allow you to build a picture up layer by layer. Acrylic paints can be combined with different materials and fillers and offer an incredible number of experimental possibilities.

Acrylic paint comes in basic, student, and artist or professional grade. The difference lies in the quantity and quality of the raw materials and pigments. The higher the pigment concentration, the better the paint's vibrance, brilliance, and color depth. Paints can appear different from different manufacturers.

DILUTING ACRYLIC PAINT WITH WATER

Diluting acrylic paint with water makes it more transparent. You can use this for glazing techniques or to paint soft backgrounds and color gradients. Make sure you use high-quality paint. If you want to store your diluted paint longer, use distilled water instead of tap water. This prevents the formation of mold.

THINNING

Thinning the paint with an acrylic binding agent or painting medium makes it more fluid without diminishing its intensity. A painting medium improves the transparency, depth, and fluidity of the paint mixed with it.

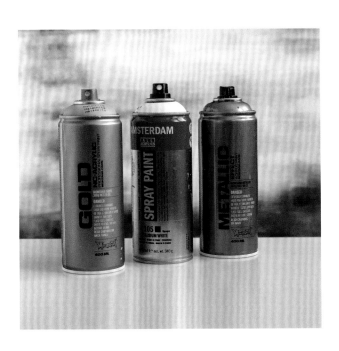

ACRYLIC SPRAY PAINT

You can use spray paint for surface designs or to spray a stencil. Spray cans with acrylic-based matte paint are easy to handle, produce minimal vapors, and do not drip. The paint dries quickly and is weather resistant. By repeatedly applying thin layers, you can create color gradients and shading. Be sure to use the manufacturer's recommended safety equipment when using spray paints.

CANVAS FRAMES AND CANVAS

You can apply acrylic paint to almost any grease-free surface. Canvas frames are made of wood with a canvas stretched across the top. Commercially-available, covered canvas frames come in all standard sizes. Canvas frame depth can reach to 1⅝″ (4.5 cm).

Colloquially, the canvas frame is also simply called a canvas. Most canvas fabric is made of cotton or linen. Good quality canvas has a fabric weight of at least 10 oz (300g/m²). The canvas should be stabilized on the back and the frame should have a thickness of at least ¾″ (2cm).

PAINTING AGENTS

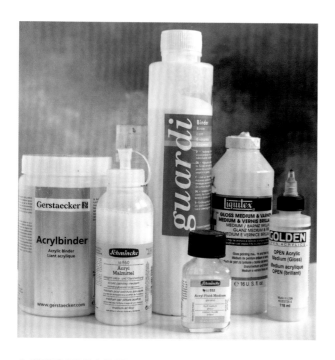

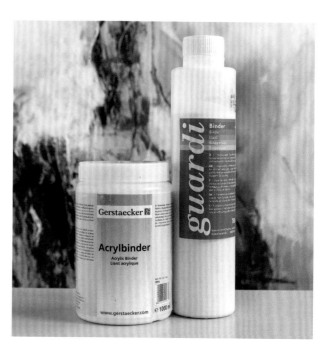

ACRYLIC PAINTING MEDIUM

Acrylic painting mediums change the properties of acrylic paints. You can use a glazing medium or thinner to dilute your acrylic paint without it losing luminosity. The color will remain intense. These painting mediums are suitable for painting in layers.

ACRYLIC BINDERS

Acrylic binders are extremely popular in acrylic painting. When preparing acrylic paint, the binder serves as a thickening agent. It consists of pure acrylate and water and is well-suited for various painting techniques. Because of its viscosity, it can be diluted with water, and once dry, is transparent and waterproof. With its slightly tacky nature, acrylic binders are a popular adhesive for material paintings and collages. Binders can be used for glazing when mixed with diluted acrylic paint. The acrylic binder can also be applied in several layers on painted surfaces to act as an intermediate varnish. Once dry, more layers of paint can be applied on top of it. By adding stone powder, chalk, marble powder, ash, or sand, you can create interesting textures.

PUTTIES, TEXTURE PASTES, FILLER COMPOUNDS

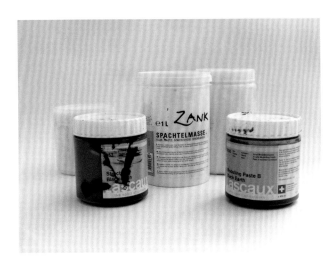

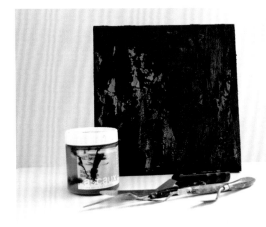

PUTTIES AND MODELING PASTE

Acrylic putties are well-suited for creating textures. They are applied in thick layers to create textured surfaces. You can paint over putties, and they can also be easily colored using acrylic paint. You can create additional effects with various filler compounds such as sand, ash, or granules.

COLORED MODELING PASTE

Black modeling paste is available in fine, rough, and extra rough grade. These deep black pastes dry waterproof and can be used pure or blended. They will not break even when applied in thick layers.

VARNISH

You can use a varnish to finish your paintings. This protects them from dust, dirt, and moisture. Some varnishes contain a light protection agent that shields the colors from UV rays. Varnish comes in matte, satin, and gloss finishes.

Acrylic paints are resistant and don't always need a final varnish. Still, think about whether a final treatment is necessary, especially when painting experimentally.

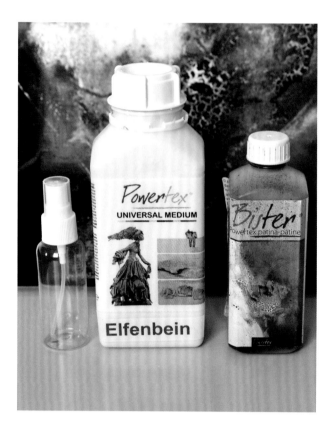

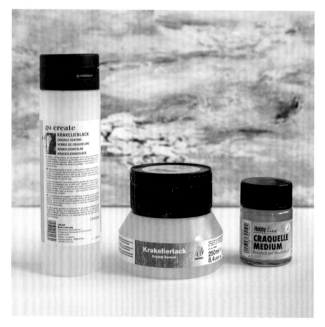

POWERTEX UNIVERSAL MEDIUM AND BISTER PATINA

Powertex Universal Medium is actually a textile hardener. However, the medium is versatile and well-suited for creating special effects. You can mix it with pigments, sand, iron powder, and other materials.

Liquid Bister Patina is a brown water-based patina. It can be washed off the canvas and is matte after drying. You can create impressive crackle effects with Powertex medium and Bister patina.

CRACKLE VARNISH

You can create deliberate cracks in your acrylic surfaces using a technique called "crackling." A special crackle medium, or lacquer, is applied for this purpose. The lacquer contracts as it dries and leaves clear cracks and fissures on the surface.

SAND AND ASH

Bird sand is one of the most popular materials to mix with acrylic paint. Another good mixing option is sand brought back from a beach vacation. Make sure all the materials you use are dry.

Ash is another interesting filler compound. Mixed with acrylic binder or putty, you get wonderful effects that look like stones.

TOOLS & ACCESSORIES

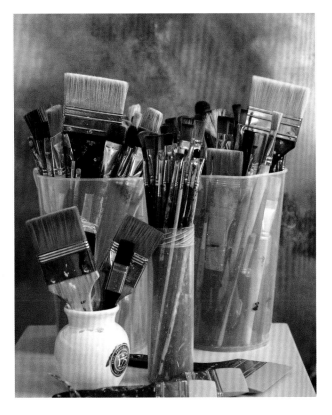

SYNTHETIC BRUSHES
Classic synthetic flat brushes are strong enough to apply acrylic paint and supple enough to apply liquid paints evenly and without streaks. With proper care, synthetic mixed-hair brushes are durable and thus recommended for acrylic painting.

BRUSHES
There are countless brushes available for acrylic painting; synthetic hair, bristle, or natural hair brushes. The type of brush determines how you apply the paint. A good brush is elastic yet strong enough to keep its shape after use. The quality of brush is crucial to achieving a good artistic result.

BRISTLE BRUSHES
Bristle brushes are robust and stiff. They are ideal for *impasto* and granulating color application.

FLAT OR SPALTER BRUSHES

A wide synthetic flat, or Spalter, brush with a short handle is well-suited for blending color. It also works especially well for applying glaze.
To clean these brushes, wash them with lukewarm water and curd soap.

SPLATTER BRUSHES

Splatter brushes have long, durable nylon fibers that are strong and long-lasting. Use a splatter brush and diluted acrylic paint to create beautiful splatter effects.

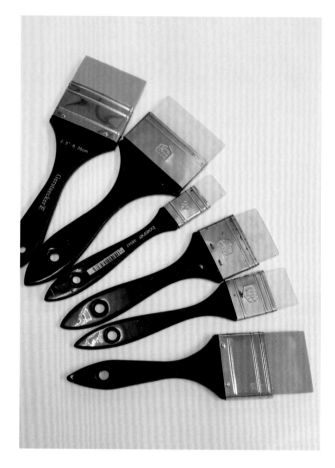

COLOR SHAPERS

These wide rubber brushes are a popular painting tool for creating unusual effects, textures, and gradients.
With a color shaper, you can apply colors, mix them on the canvas and create freestyle designs.

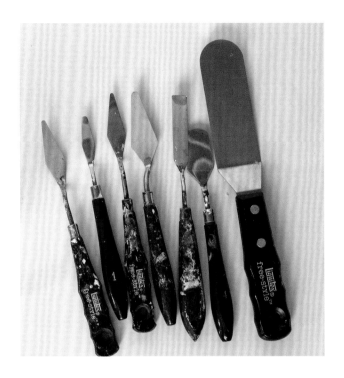

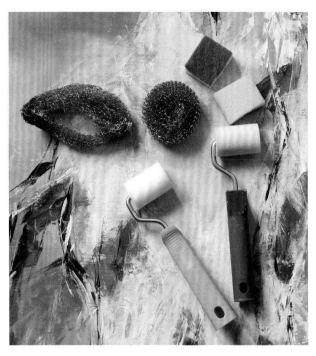

PALETTE KNIVES

A palette knife, also called a paint spatula or paint knife, consists of a brass blade and a wooden handle. Palette knives come in different shapes and blade lengths. A good palette knife has a flexible metal blade. You can use a palette knife to apply thick paint or putty to canvas, smooth it out, or texture it. They are also suitable for mixing colors on the painting palette. You can use the edge of the blade to draw fine lines and also use it to scrape into wet paint. Large palette knives are suitable for working on large-format canvases.

PAINT ROLLERS, SPONGES, AND SCOURERS

You can easily create interesting textures when painting by using a foam roller from any hardware store. A small roller with a foam surface is best suited for this and it's also ideal for painting narrow stripes. When you apply the paint, make sure the roller is completely saturated all the way around.

A simple household sponge works great for spreading paint to create beautiful gradients.

You can use steel wool to scratch interesting grooves into paint that has not yet dried. Paint applied sparingly with a scourer will leave fascinating markings on your painting.

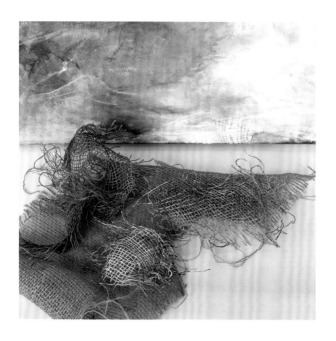

BURLAP

This coarse jute fabric is always a handy material. If you pull the fibers apart a bit and spray it with acrylic spray like a stencil, you get a richly-varied checked pattern.

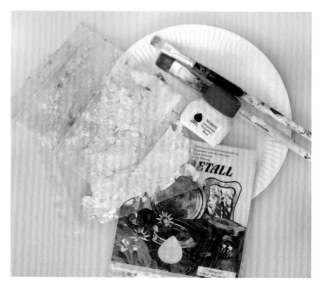

METALLIC FOIL

Metallic foils or metallic foil flakes are ultra-thin metal shavings that come as flakes or leaves. You can use foil flakes to enhance your images and for decorative design. The delicate metal flakes are glued on with gilding size and then smoothed out with a soft brush.

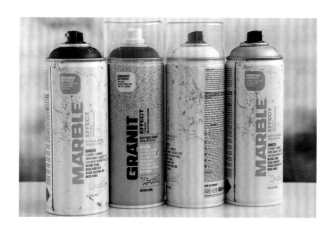

MARBLE EFFECT SPRAY

This special spray paint can be used on many surfaces. The marble effect is created by fine, colored paint threads along the surface. Instead of being completely covered, the sprayed surface remains partially visible.

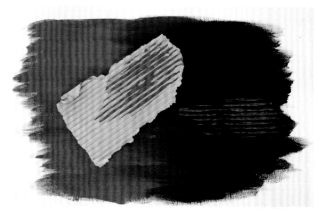

CORRUGATED CARDBOARD

Corrugated cardboard is a very versatile material. You can use it to leave impressions in putty, incorporate smaller pieces into collages, or create colorful, geometric prints like this one.

YOUR BASIC EQUIPMENT

Red, yellow, and blue—these are the three basic colors you need to get started. I recommend cadmium yellow, cadmium red, and ultramarine blue, as well as white and black. You'll use white to lighten the colors, so you will need a lot. You can't make a rich, true black by mixing the other colors together, but it's useful for creating dark accents or strong contrasts. It doesn't hurt to expand your color palette a bit and buy a few shades to try out in tubes. For example, primary magenta, primary yellow, primary cyan, and phthalo green.

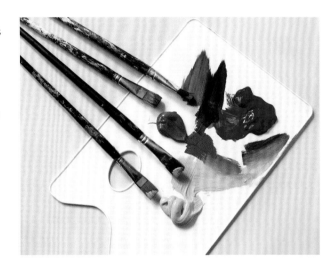

YOU WILL ALSO NEED:
- Canvas size 16″ × 20″ (40 × 50 cm) or 20″ × 20″ (50 × 50 cm)
- High-quality acrylic paint brushes
- Synthetic flat brushes sizes 10, 16, and 24
- Splatter brushes in size 20 and size 30
- Color shapers in sizes 1.5 and 2
- Palette knife or set of palette knives
- Acrylic binder to thin colors and to make your own textured pastes
- Paint roller/foam roller from the hardware store

FOR THE TECHNIQUES DEMONSTRATED IN THIS BOOK, YOU WILL ALSO NEED:
- Powertex Universal Medium in Ivory
- Liquid Bister Patina
- Small container of iron powder
- Small spray bottle
- Fine putty, without added granules
- Palette or paper plate
- Cloths or paper towel

CREATING MIXED-MEDIA EFFECTS

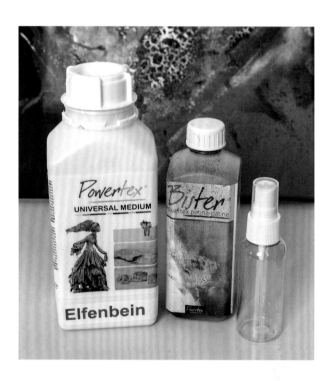

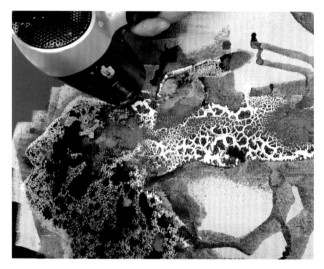

Blow-dry in one area until the first cracks and fissures appear. Since Bister Patina is water-soluble, you can wipe away the drip marks created during the blow-dry. It works even better with a heat gun: The surfaces fracture faster and there are no drip marks. Your painting definitely needs a final varnish once complete.

CRACKED EFFECTS

FOR STUNNING CRACKLE EFFECTS,
YOU WILL NEED:
Powertex Universal Medium, Bister Patina, small spray bottle, paper for covering, and a hair dryer or heat gun

Using a palette knife, apply the Powertex medium to the desired areas on the surface of your canvas. The more of the medium that you apply, the rougher the fissures will be later. Pour the Bister Patina into a small spray bottle. Cover the remaining canvas surface with paper to protect it from paint splatter. Now spray the Powertex generously with the Bister Patina. Remove the paper before you start blow drying.

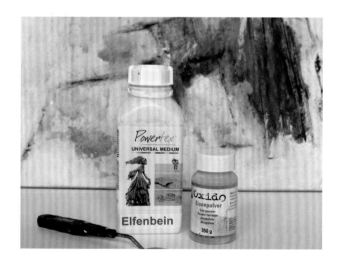

RUST EFFECTS

Rusty-looking surfaces are another way of creating interesting effects. You can use Powertex Universal Medium and iron powder to create an iron primer.

FOR RUST EFFECTS YOU WILL NEED:

Powertex Universal Medium, iron powder, palette knife, small spray bottle, painting palette or paper plate, water, and vinegar

Put some Powertex Universal Medium and iron powder on a paper plate. With a palette knife, mix both substances into a gray paste and apply it to your canvas. Fill a small spray bottle with a 1:1 ratio of water and vinegar. Shortly after spraying, the treated surface will become coated with rust. You can intensify this effect with repeated spray applications.

Once the first layer of paint dries, you can apply the crackle varnish. You can put the crackle varnish on a painting palette first or spread it directly onto the canvas. The varnish must dry before you apply the next layer of paint. Drying times will vary based on the manufacturer's instructions. The more varnish you apply, the greater the crackle effect will be than if you only apply a thin coating.

CRACKLE PAINTING

Another way to cover your painting surface with fissures is to use the crackle paint technique.

FOR CRACKLE EFFECTS, YOU NEED:

Crackle varnish, brushes, and acrylic paint

To get nice, clearly-visible cracks and fissures, the colors of the top and bottom paint layers should be noticeably different. For this example, I chose red and black for the bottom layer, and white for the top.

Since the varnish becomes transparent as it dries, the background will show through. Using a brush, apply paint to the dry crackle varnish. The dried varnish absorbs the water from the paint and becomes damp again. The stroke path of the brush determines the direction of the cracking, which will start within seconds. Let the painting dry while flat so that the chunks of paint do not shift.

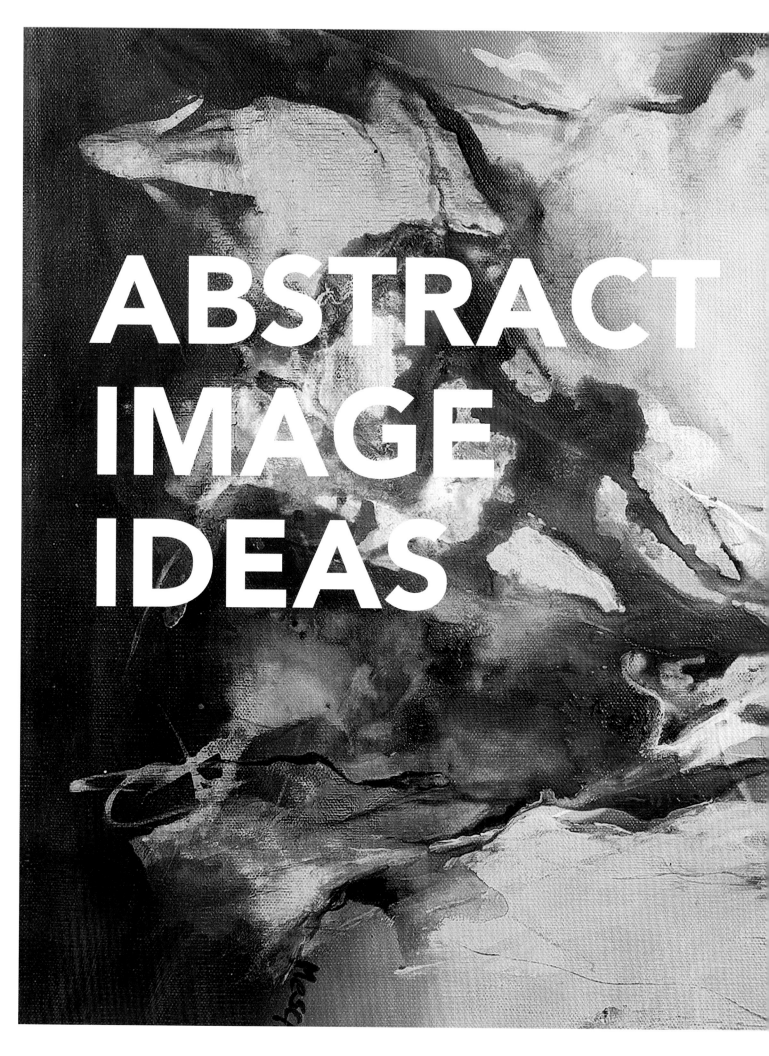

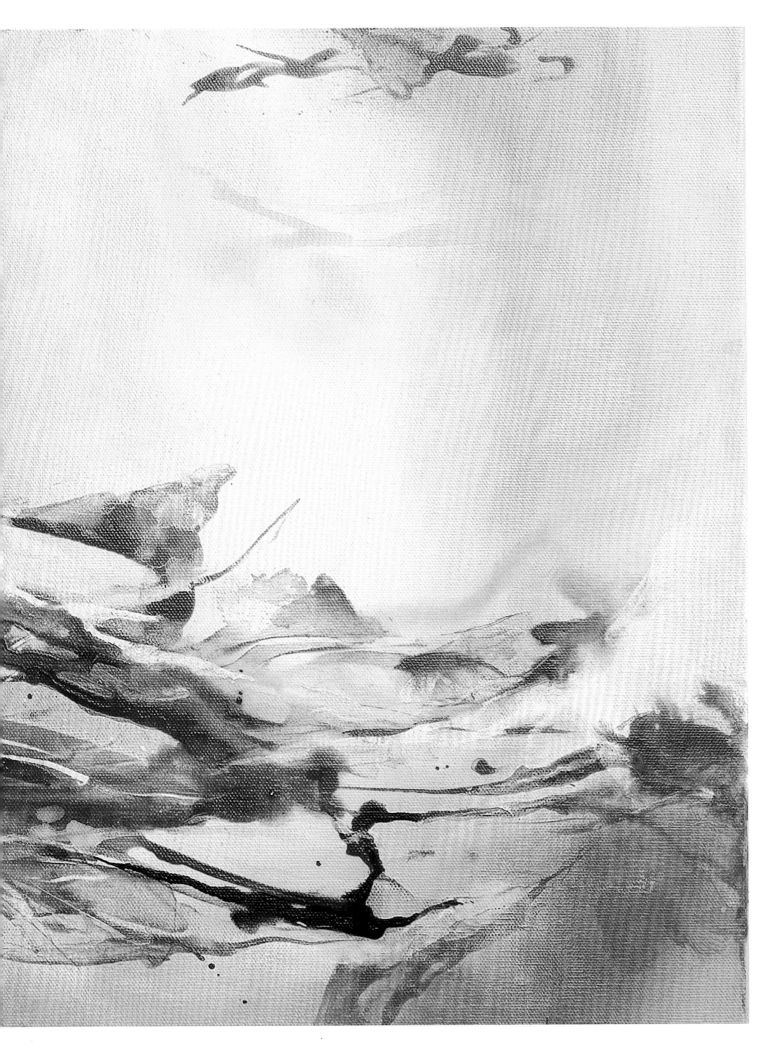

TOPSY-TURVY

SEEKING SIGNS IN COLOR

MATERIAL

Stretched canvas or
canvas board
20″ × 20″ (50 × 50 cm) or
30″ × 30″ (80 × 80 cm)

COLORS

Crimson, pastel yellow,
cobalt blue, fern, phthalo
green, black, and white

BRUSH

Flat brush size 24

Steel sponge and
plastic wrap

Light and dark, large and small, make up the contrasts in this varied composition. The color itself serves as a means of expression and is a source of inspiration, creating an image that conveys tension and harmony at the same time.

TECHNIQUE

The *sgraffito* technique is a method in which you use a tool to scratch into a paint layer to reveal the underlying color. In the simplest form, the two-color *sgraffito*, there are three layers of paint on top of one another. This impression technique done with plastic wrap creates interesting fractured effects.

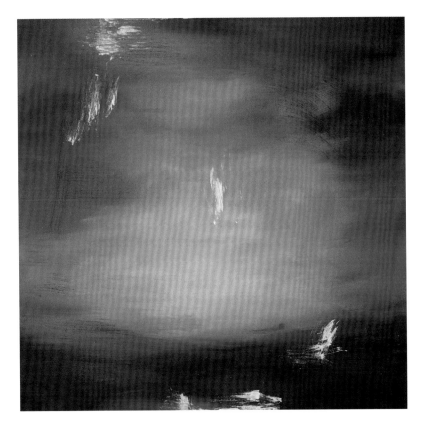

1 Start by covering your entire canvas with the crimson and applying it impasto. This layer must dry thoroughly. For the second, blue layer, use a flat brush. Apply the cobalt blue to the edge of the canvas, and the white to the center. Spread the paint in such a way that a light blue tone emerges in the center. Avoid painting in only one direction, but rather use both sides of the brush. Next, using a steel sponge, scratch lines here and there across the still wet surface of the blue paint layer. The underlying red layer will be exposed and show through. Don't scratch so much that the painting becomes too jarring.

2 Coat the plastic wrap with red paint using a brush. The paint should not be too runny, but should have a solid consistency. Now, carefully place the painted wrap in the center of the canvas and press down firmly. Be careful not to slip when pressing down the plastic. Also, distribute slightly smaller red plastic wrap prints in the upper and lower sections of the canvas.

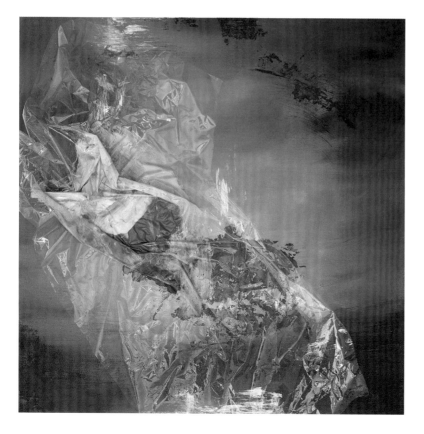

3 Now coat a piece of wrap with two other colors, then place the wrap next to where you applied red paint and press it down onto the canvas. After the new colors have dried, repeat the print technique with blue, black, and pastel yellow. Press the plastic wrap onto the red color in different places. This creates expressive patterns and great effects.

4 Once the paint is dry, add a few additional swipes of paint to the surface with the steel sponge. This emphasizes the texture even more. Finally, you can apply a glaze of red. Mix a drop of red paint with plenty of water and spread the glaze on your canvas with a soft brush.

TIP: When applying color, remember that less is often more. Include the entire composition in your planning and use colors sparingly.

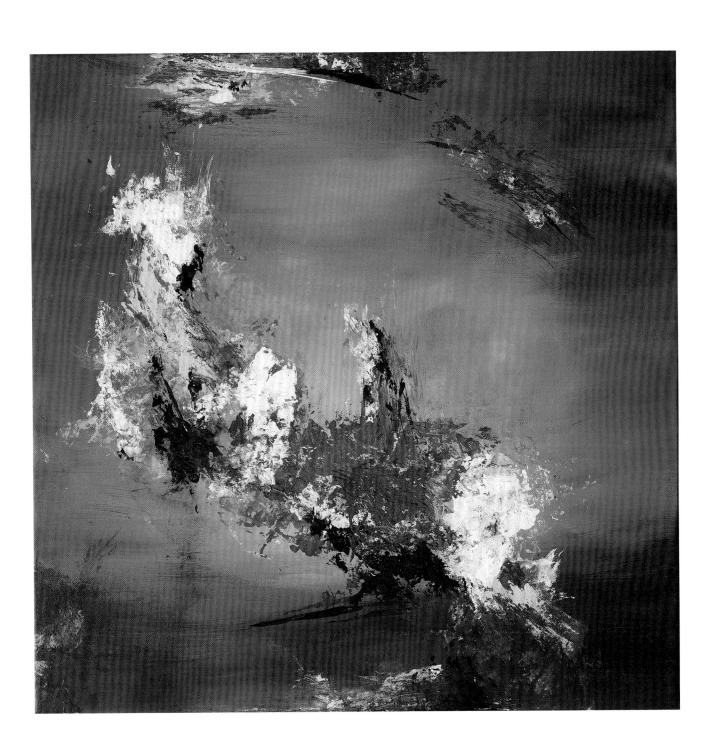

WHAT A FEELING

EVERYTHING IS ILLUMINATED

MATERIAL

Stretched canvas or
canvas board
20″ × 30″ (50 × 70 cm)

COLORS

White, golden green,
fern, phthalo blue,
turquoise, and black

Acrylic spray in white
and turquoise

Brushes, fine putty,
sponge, palette knife,
and burlap

This abstract design doesn't just radiate a warm and sunny atmosphere through the golden green background; each color that is applied actively interacts with the adjacent colors. The balance creates both harmony and contrast and is crucial for a successful composition.

TECHNIQUE

Your main tools for this design are a sponge and a palette knife. The image is created on a surface that has been pre-primed with putty. To prime with putty, it is best to use a palette knife. For the first paint application, use a sponge, with which you can combine the colors well. The bright and transparent gradients create a luminous background.

Apply the contrasting shades of blue, black, and turquoise with a palette knife. Finally, set accents with the help of burlap fabric and speckling.

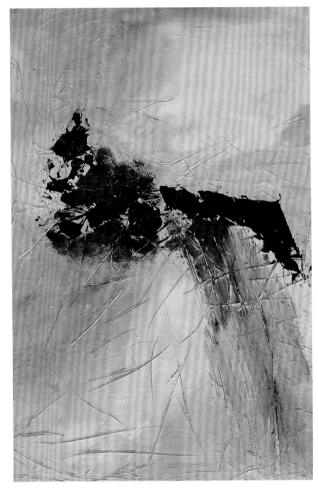

1 First, spread the putty over the entire canvas using a palette knife. Draw curved lines in the still-wet putty with the knife's edge. This creates a textured background. Then, apply the fern, golden green, and white paints next to each other on a painting palette. Take up the paints with a sponge and wipe them over the dried putty. Blend the colors into each other, tone-on-tone, in such a way that a lighter section is created at the bottom left and the top right. Blending the colors in this way creates a serene background.

2 Now take the palette knife and apply black and phthalo blue to the center of the canvas. Using a damp sponge, spread the phthalo blue far into the lower right corner of the canvas. Add a little water to create a fine, transparent color transition.

TIP: Repeated colors create harmony. Distribute the same color in different sections of the painting.

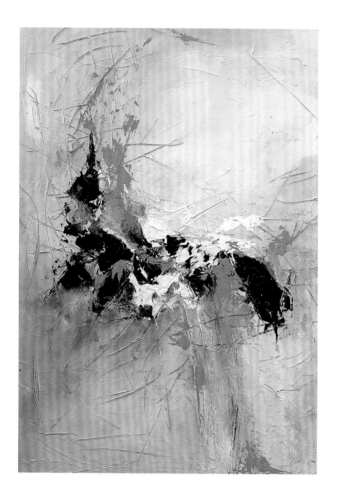

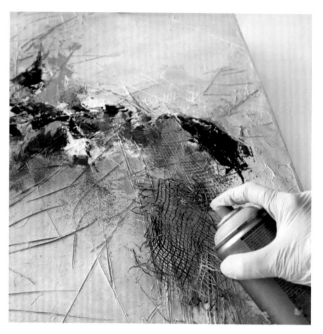

4 Place a burlap net on the lower section of the canvas and spray it with turquoise acrylic spray. You can repeat this step in the upper section using the white acrylic spray. Therefore, you create areas with grid-like patterns, which give the painting more intensity.

Finally, create accents by diluting some turquoise with water and use a toothbrush to add sprinkles of color to your painting where desired. The turquoise speckles make your motif more dynamic and act as the icing on the cake of your creative acrylic painting.

3 On a painting palette, use a brush to dilute white paint with a little water. Then use a sponge to spread this mixture over the lighter areas of the painting. By adding more water, you get more delicate shades of color that you can temper as you move to the upper right corner of the canvas. The result is an incredibly soft color gradient.

Once the paint has dried, use a palette knife to apply turquoise on top of the black. Do not cover everything but apply the paint so that the underlying colors are still partially visible. Use the palette knife to move the turquoise outward, then apply white with the palette knife in the same way, drawing the color toward the lower edge with a sponge.

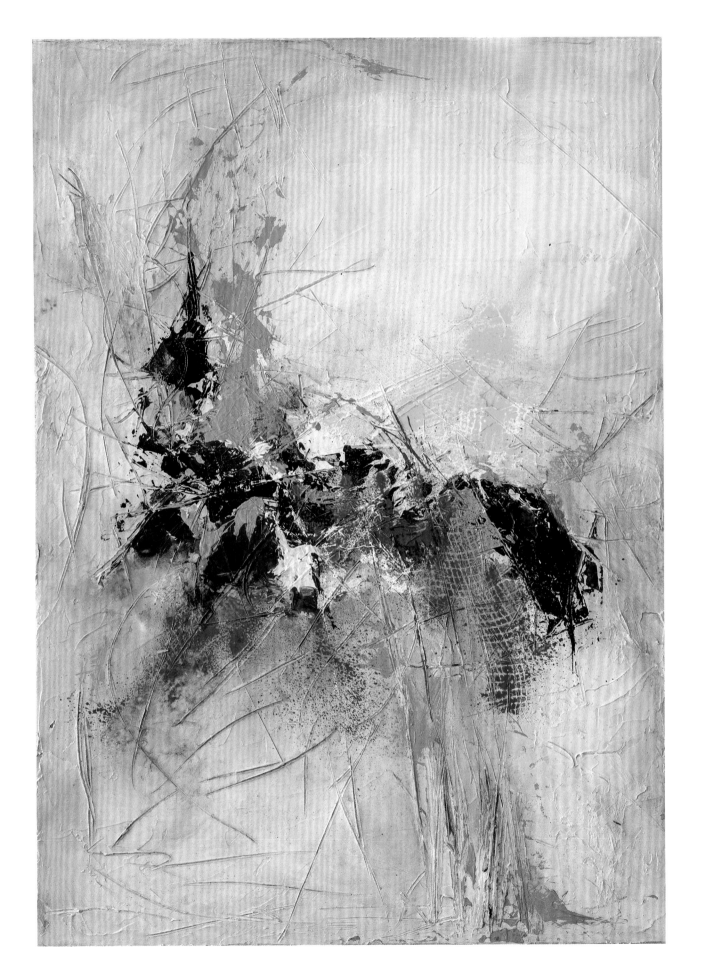

WATERFALL

BLUE WONDER WITH RUST EFFECTS

MATERIAL

Stretched canvas or
canvas board
20″ × 20″ (50 × 50 cm)

COLORS

White, orange, sand,
cyan (primary blue),
phthalo green, and
Payne's gray

Powertex Universal
Medium, iron powder,
vinegar, small spray
bottle, small container,
foam roller, acrylic
brush, palette knife,
paper plate or
painting palette, and
finishing varnish

The rusting process is a natural occurrence. Rust develops when iron comes into contact with moisture and oxygen. This also occurs in nature, for example, when water runs over ferrous rocks. These two waterfall pictures are artistically interpreted images or rusty trails created by nature.

TECHNIQUE

Allowing surfaces to rust is a charming means of expressing weathering in an image. Patinating the surface emphasizes the intriguing artistic effects in the image and reflects transience. There are several ways to create rust in an image. For this painting, Powertex Universal Medium, iron powder, and vinegar were used.

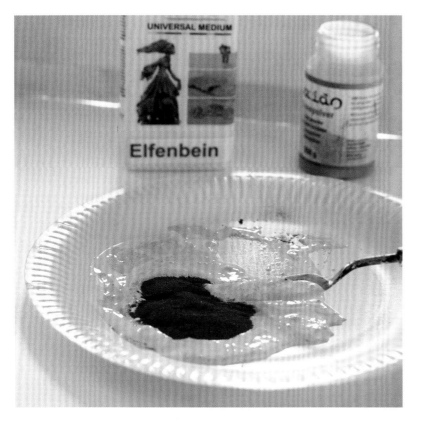

1 First, prepare the background for painting. Apply white paint on your painting palette and add a little orange—not the other way around. After mixing the paint this way, cover the entire canvas and then allow it to dry.

Now prepare the iron primer. Pour the Powertex onto a paper plate and sprinkle the iron powder on top. Blend the mixture with a palette knife. Add as much iron powder as needed until the blend turns gray. Next, apply the finished mixture to the upper left and right sides of the painting using the palette knife, smudging the hard edges outward. Set the leftovers on the palette aside. You will need them later.

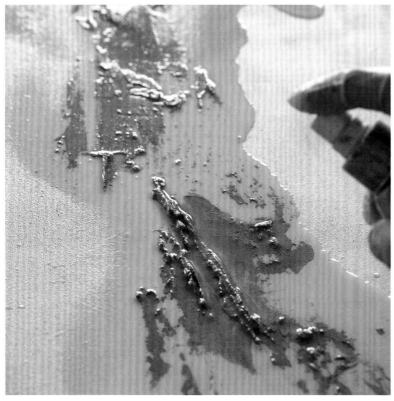

2 Now you can rust the iron primer. Fill a small spray bottle with vinegar and water in a 1:1 ratio and spray the iron mixture with it. Then you have to wait. After about 20 minutes, the first rust effects will be visible.

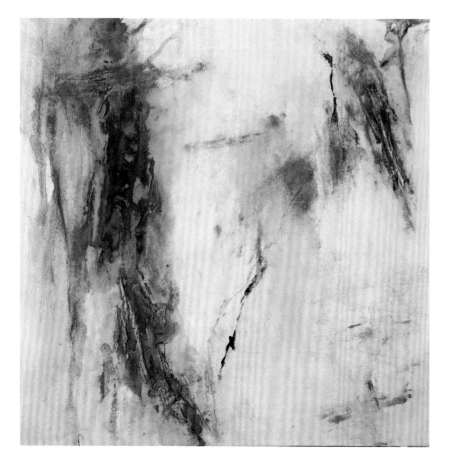

3 In a small container, dilute Payne's gray with plenty of water to make a very transparent paint. Pour the diluted paint over the picture from the top left and let it flow by lifting the canvas slightly. Using a palette knife and Payne's gray, spread a few more lines out in the painting to emphasize the movement. Pour a little vinegar water on the painting palette with the remains of the iron primer and mix it all together with a brush. Pour the mixture onto the center of the canvas to join the rusted areas. Then let everything dry well.

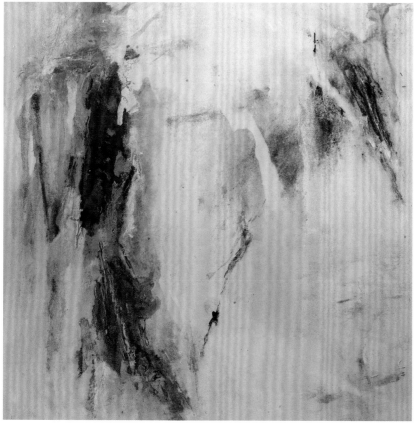

4 Take up the diluted white paint from the paper plate using your foam roller. Make sure that the roller is completely covered by the paint. Now roll over your canvas with the paint roller. Avoid the rusted parts. In the upper section of the picture, spray the white paint with water and let it run over the canvas.

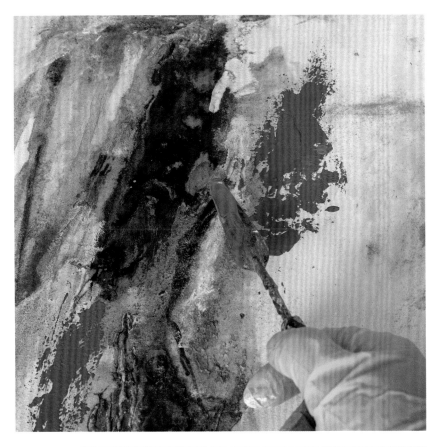

5 When everything is dry, the next step is to apply paint with the palette knife. To do this, apply thick blocks of color in phthalo blue with the knife and rub them in at the edges. Mix cyan with white on your painting palette to create a light blue tone and apply this color with the palette knife as well.

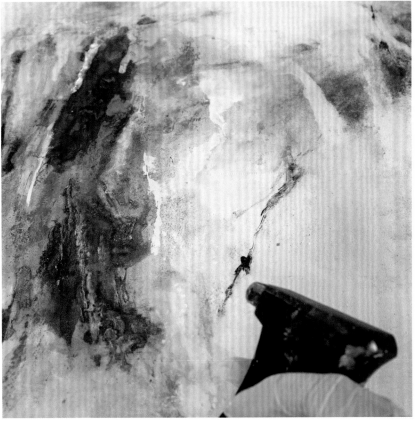

6 Finally, spray your paint applications with water from the spray bottle. This creates a transparent layer that disperses nicely.

TIP: If you are hooked on a theme, there's nothing stopping you from painting several related pictures. As soon as you choose different colors or a different composition, the painting will turn out entirely different.

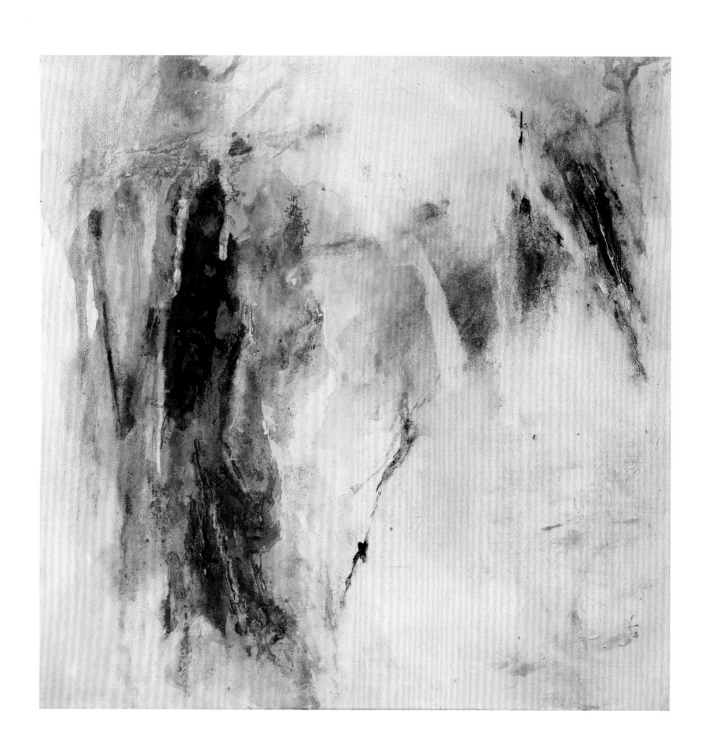

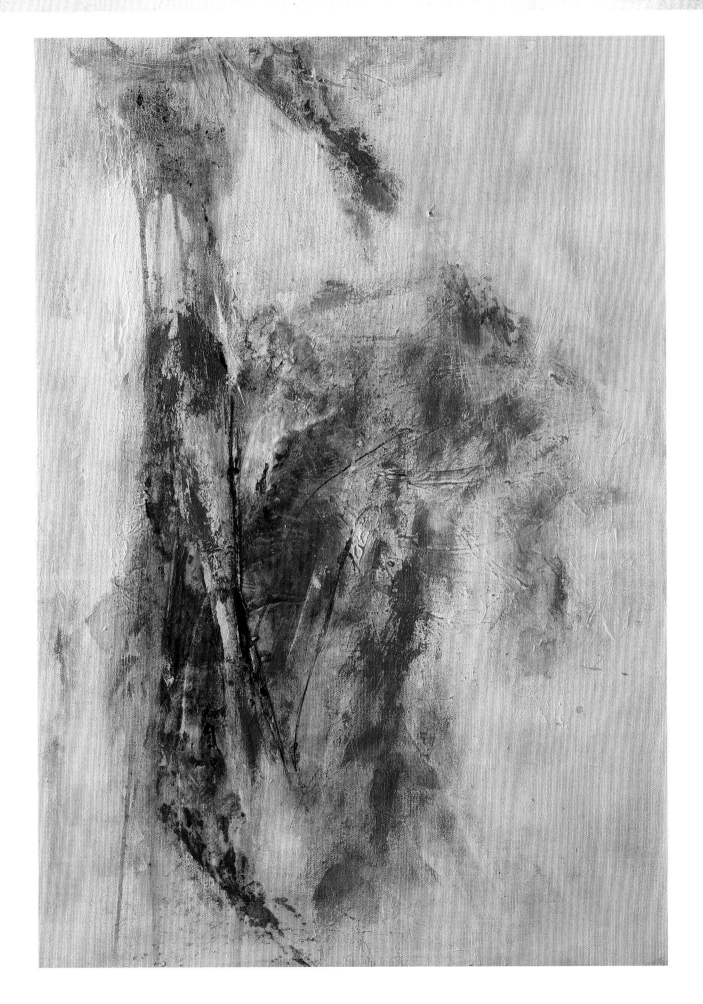

SIGN OF THE TIMES

WEATHERED TRACES

MATERIAL

Stretched canvas or
canvas board
20″ × 28″ (50 × 70 cm)

COLORS

Brown, Naples yellow,
cobalt blue, black, and
white

BRUSHES

Flat brush size 16
Bristle brush size 14

Painter's tape, ash,
acrylic binder, foam
roller, painting palette
or paper plate, steel
wool, crackle varnish,
and a small container

This painting gives the impression of old masonry. This illusion is repeatedly built up and constructed through multiple layers. The black and white contrasts, as well as the dynamic shapes and their fine fraying, enhance the effect. Cracks and scratches add to the impression of weathering.

TECHNIQUE

To give the painting its weather-beaten character, you will need to use several techniques. Combine layers of overlapping paint with scratch marks and cracks. Use a mixture of acrylic binder and ash to add special effects. Finally, use a brush to granulate contrasting colors and pour diluted white over your painting.

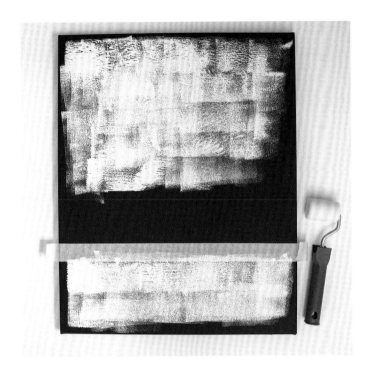

1 First use a wide, flat brush, and black paint to cover the entire surface of your canvas. The paint should be thick enough to leave no white spots. Let the paint dry well, then use painter's tape to fix a straight line across the lower third of the painting. You can measure the distances with a ruler. Secure the tape well, especially near the edges, so that no paint seeps underneath. Now use a foam roller to apply white paint and distribute it over the entire surface. Leave some of the black border along the sides.

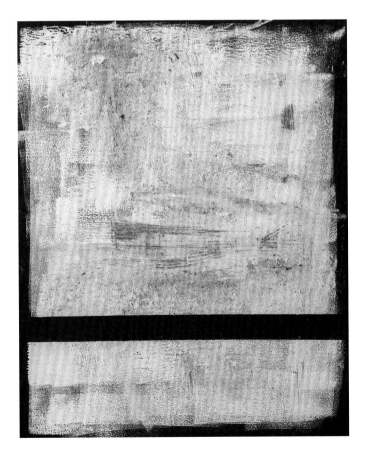

2 In this next step, mix ash and acrylic binder together on a paper plate to form a dense paste. Then apply the mixture to your canvas with a foam roller. Since the foam roller is very absorbent, it's best to mix larger quantities of the paste and spread it across your painting. In addition, use steel wool to scratch into the still wet surface. Immediately after you have applied the compound, carefully remove the tape.

TIP: The more layers you apply, the more interesting the painting's surface will be. Since each layer needs to dry for a long time, it's best to work on two paintings at once.

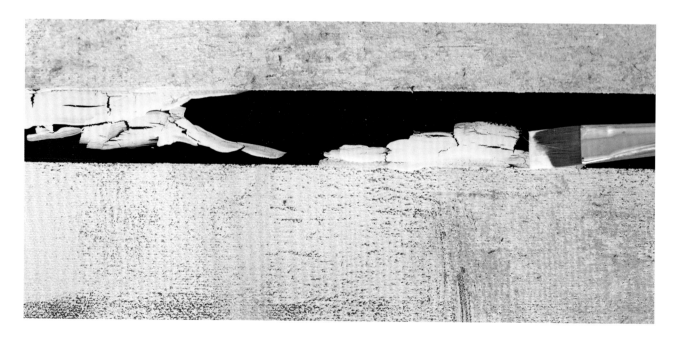

3 Next, use a brush to apply the crackle varnish to the exposed black area. You can cover the entire strip with the varnish, or just specific areas. When applying, make sure you only paint in one direction. Too many strokes in different directions can disturb the result. Apply the crackle varnish to a few areas of the canvas and along the edges. The coarser you want the texture to be, the thicker you need to apply it. Then, let the varnish dry. Create a nice contrast to the layer underneath by painting the black areas with white paint.

4 Apply a lot of color with the flat brush, using short strokes over the crackle varnish. Do not paint over the same area too many times or you may destroy the structure of the crack. In the upper part of the canvas, apply a coat of paint in Naples yellow over the dried paint layer. The dried crackle varnish draws moisture out of the paint and becomes wet again. You can see the crackle effect after a few seconds. Let your painting dry flat, so that the paint and varnish do not shift.

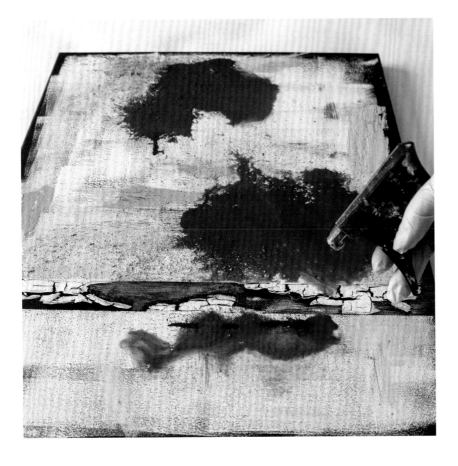

5 Things get really exciting now: In this step, pour diluted colors onto your painting. Mix brown with water using a 1:1 ratio and pour that mixture onto the canvas. Then, spray the canvas around the section with the poured paint. The paint will combine with the water and spread in gentle streaks across the canvas. Let everything dry well.

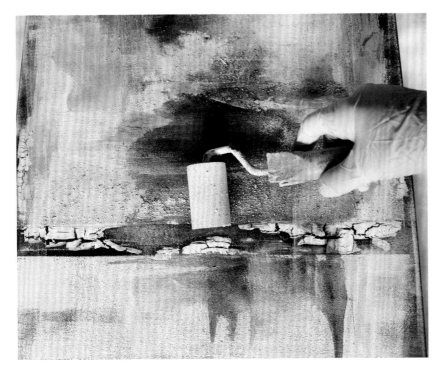

6 Now to make sure your painting has a smooth look. Apply white paint to a painting palette and mix it with a little water. Coat the canvas with this transparent mixture using a foam roller. Use it to cover all the hard contrasts in the picture. Let it dry well again.

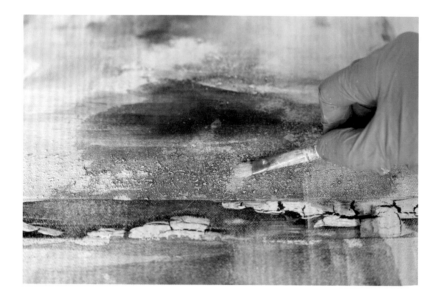

7 Next, it's time to move on to granulation. Apply a little undiluted Naples yellow with a dry bristle brush. Dab the brush on a palette—hardly any color should remain on the brush—and lightly stroke the rough surfaces of the image. The paint will adhere to the raised areas and create a grainy coating. Repeat the same technique with a light blue tone mixed from cobalt blue and white. Add granulation in various rough areas of the painting.

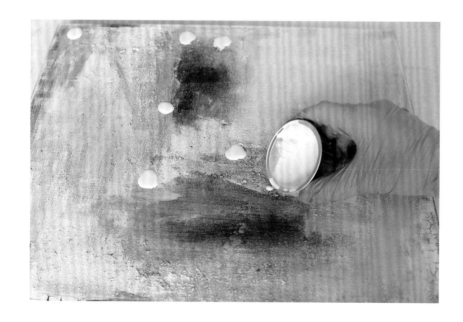

8 Your painting is almost ready now. To finish, dilute white paint with water in a container. Put a few drops of the diluted paint on the canvas and spray it with water from the spray bottle. Lift the canvas slightly so that the paint can flow over the picture. When everything is dry, you can seal your picture with a final varnish.

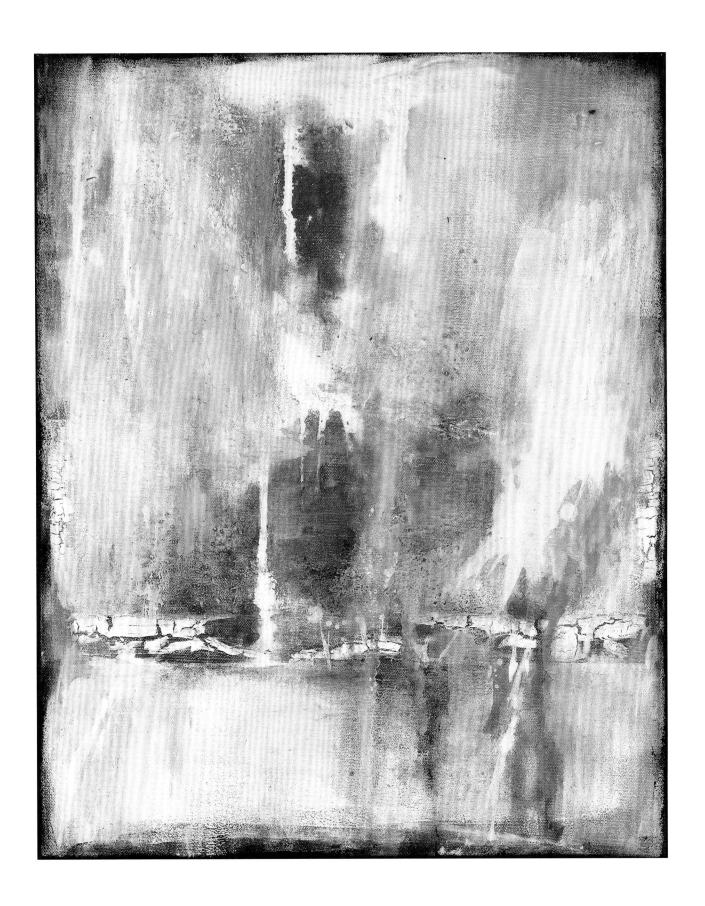

LOST PLACES 1

BRITTLE CHARM WITH CRACKS

MATERIAL

Stretched canvas or
canvas board
20″ × 28″ (50 × 70 cm)

COLORS

Steel blue, white,
and black

BRUSH

Flat brush size 24

Powertex Universal
Medium Ivory, liquid
Bister Patina, foam
roller, palette knife,
paper plate, small
spray bottle, and
finishing varnish in
spray can

Beautiful and abandoned places seem mysterious and always have a story. The following two abstract paintings are reminiscent of old abandoned houses. The crackle effects resemble traces of decay and lend excitement to the image.

TECHNIQUE

Use Powertex Universal Medium and Bister Patina to create expressive surfaces. The Powertex medium can be used in a variety of ways. It is excellent for creating beautiful crackle effects on the canvas. Beware, less is often more: The Powertex should only be an aid to shaping a composition and should not dominate it too much.

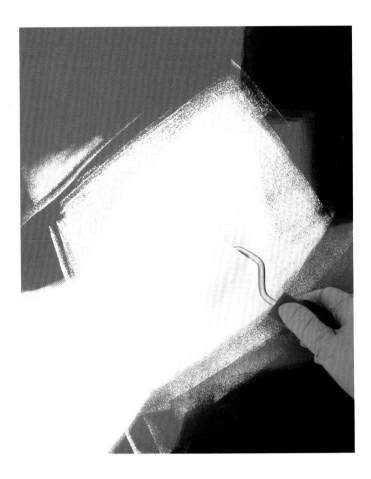

1 Use a flat brush to paint an opaque background using the colors steel blue, white, and black. Let the paint dry. Spread the white paint on a painting palette and roll over it with a foam roller until it becomes saturated with paint. Using the roller, paint a square in the center of the painting. Use the edge of the foam roller to create a few more lines.

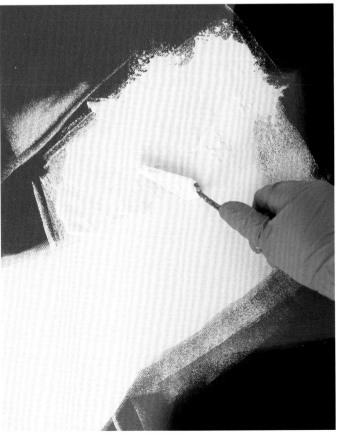

2 Now use the Powertex. Remember to shake the bottle for about five minutes beforehand so that the medium mixes well and isn't too runny. Pour the Powertex onto a paper plate and use a palette knife to spread it on the areas of the painting where you want crackle effects to appear. The thicker you apply the Powertex, the wider the resulting cracks; the thinner you apply it, the smaller and narrower the cracks.

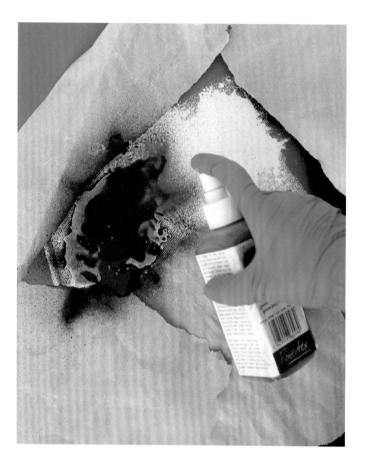

3 Now cover your canvas with paper around the space where you applied the medium. This will protect the surrounding surfaces. Pour the Bister Patina into a small spray bottle and spray where you applied the Powertex. Then, remove the paper scraps so they don't fly around when blow-drying.

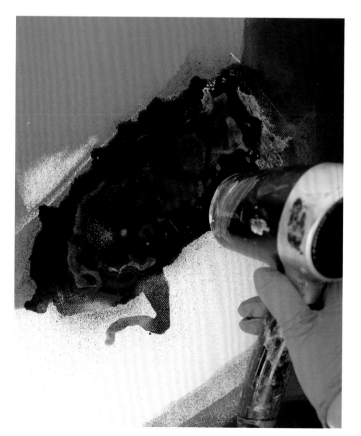

4 You will need a hair dryer to create the cracks. Direct the air stream close to the canvas in one area until the first cracks and fissures become visible. You can continue to spread the dripping traces of Bister Patina with the dryer. Since the patina is water soluble, you can remove excess drip marks with a damp cloth after drying.

Finally, apply white paint to a palette and roll over it with the foam roller. Use the edge of the roller to spread a few lines as accents to your painting. Then, using light pressure, roll diluted white paint as a transparent glaze over some sections of the painting. When everything has dried, use a finishing varnish to seal the crackle effects.

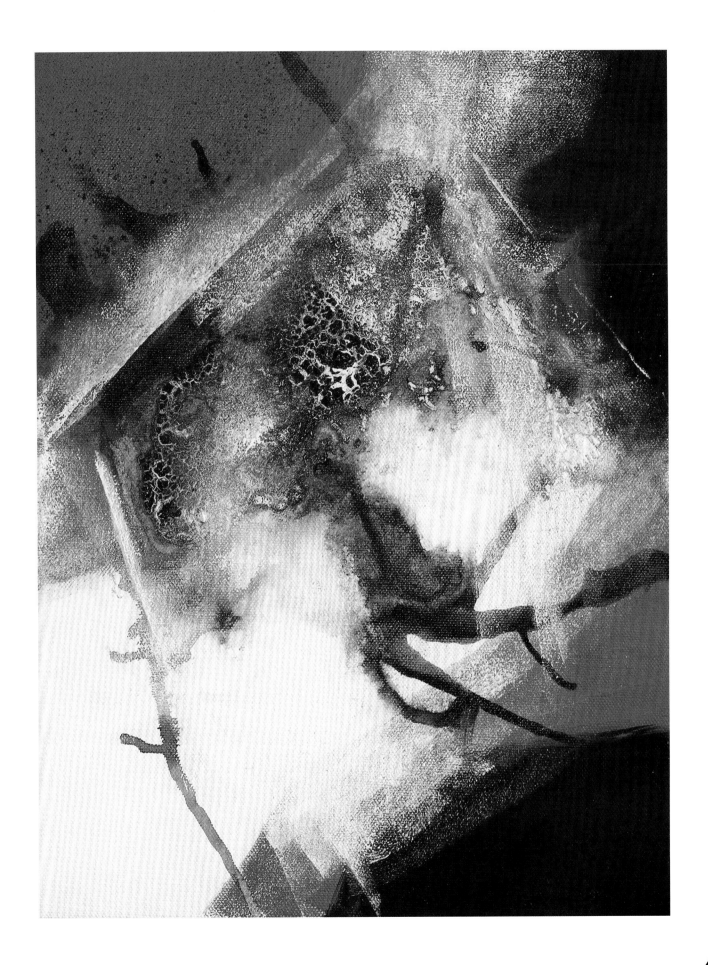

LOST PLACES 2

MAGIC OF TRANSIENCE

MATERIAL

Stretched canvas or
canvas board
20″ × 28″ (50 × 70 cm)

COLORS

Cadmium red, white,
black, and sand

BRUSH

Flat brush size 24

Powertex Universal
Medium, liquid Bister
Patina, foam roller,
palette knife, paper
plate, small spray
bottle, and finishing
varnish in spray can

The aloof allure of the morbid and decayed has a peculiar attraction for us. We feel the history that surrounds such places and become aware of the rhythm of time. Some places are reclaimed by nature, as expressed by the trace marks of the Bister Patina in these paintings.

TECHNIQUE

The technique in this painting is similar to the motif in "Lost Places 1″ on the previous pages. You can easily see how completely different images can be created despite using similar methods. Again, use the Powertex medium selectively and sparingly.

1 Use a flat brush to paint the background with the colors cadmium red, white, black, and sand. Allow the paint to dry thoroughly.

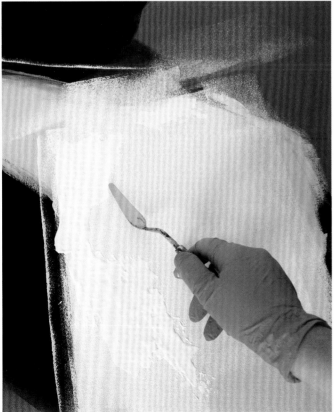

2 Spread white paint on a painting palette and roll over it with a foam roller until it is saturated with paint. With the foam roller, paint a square in the center of the image. Use the edge of the roller to draw a few more lines inside your image.

When the paint has dried, use a palette knife to spread the Powertex over the areas of the image where you want the crackle effects to appear. Remember to shake the Powertex well beforehand, pour some onto a paper plate and then spread it as desired.

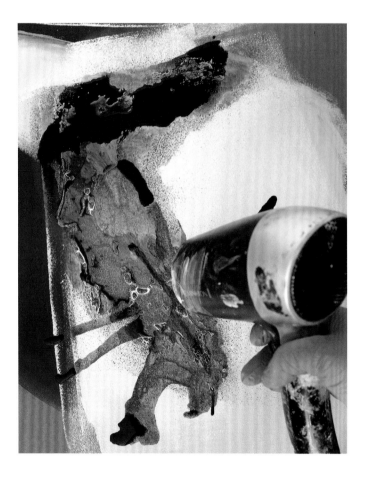

3 With a spray bottle, spray the Bister Patina over the places where Powertex was applied. You will need a hair dryer to create cracks. Direct the air stream close to the canvas in one area until the first cracks and fissures become visible. You can continue to spread the droplets of patina with the hair dryer. Since the Bister Patina is water soluble, you can remove excess patina with a damp cloth after drying.

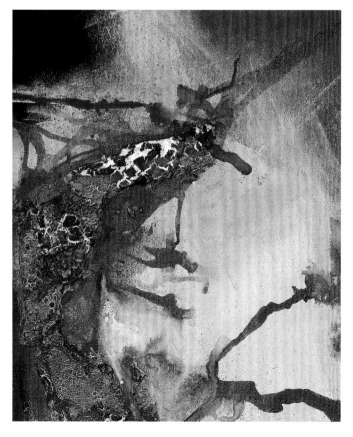

4 Finally, spread some of the sand color on your palette and roll over it with the foam roller. Reinforce a few areas in your painting with the roller and the sand tone, then set lines to further liven up the painting. Since the Bister Patina is water-soluble, please don't forget to spray your work with finishing varnish after drying.

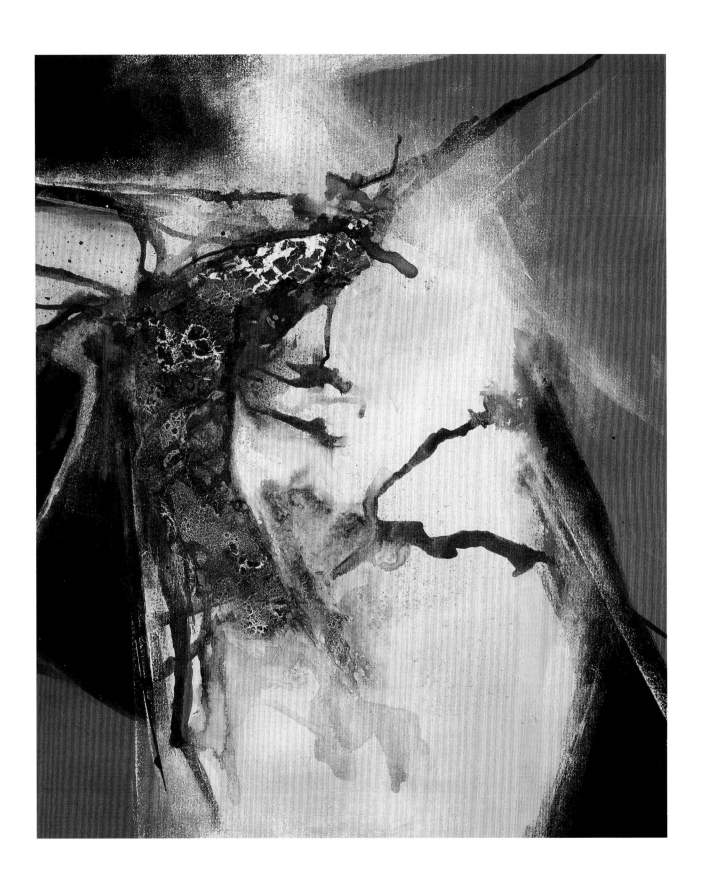

BLUE RIVER

MOVEMENT AND CHANGE

MATERIAL

Stretched canvas or
canvas board
20″ × 20″ (50 × 50 cm)

COLORS

Turquoise, light green,
cobalt blue, Prussian
blue, phthalo blue,
aquamarine, and gold

Spray bottle, acrylic
binder, palette knife,
several small paint
brushes, various
containers, gold leaf,
gilding size, and
pipette

Everything is in flux, and yet everything is connected. Movement and change create exciting and new color connections. The poured paints form close bonds with each other, dissolving their forms in the process. The application of gold leaf provides that little something extra.

TECHNIQUE

In this painting, you will use a pouring technique. You pour the paint onto your canvas and then let them run. To dilute the paint, mix with water beforehand. If you want to make a strong and opaque mixture, you need to add an acrylic binder. With pouring techniques, every painting is an experiment. The results are not predictable.

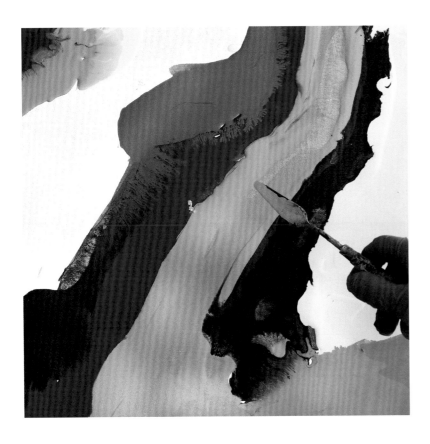

1 Before you start, dilute the paints with a little water. Use a separate container for each of the six colors. You'll know you've reached the right consistency for the mixed colors when they are as smooth as cream. Pour the first color onto your canvas and spread it with a palette knife. The color must not be spread too thinly and should be opaque. Pour the next color beside it on the canvas and spread it to the edge of the first color with the palette knife. Since acrylic paint dries very quickly, use a spray bottle to dampen with water often. Spray the water on the edges of the colors and not in the middle of the section. The colors will blend and create beautiful color gradients.

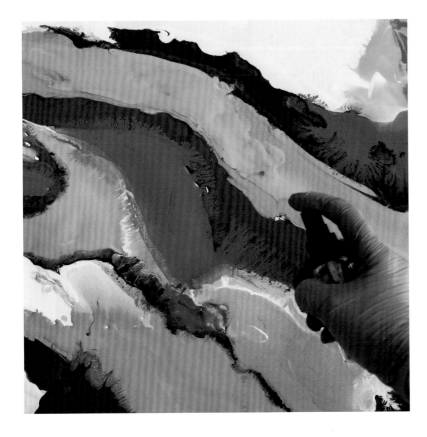

2 Cover your entire canvas with paint and spray the edges again with water from the inside to the outside. Let the paint run by tilting the canvas slightly back and forth. Then, mix gold paint with a little water in a container. Apply some paint with a toothbrush and moving from top to bottom, flick large and small droplets on the still wet background. Before moving on to the next step, the canvas must dry well.

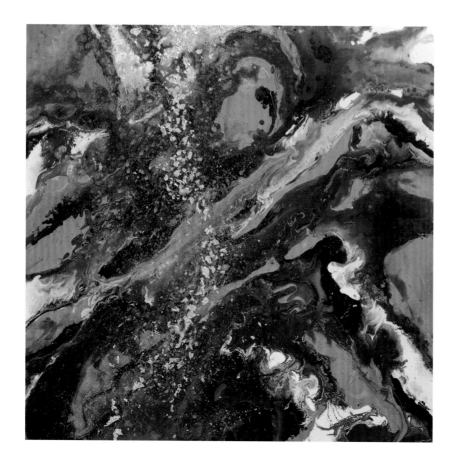

3 For that extra touch, cover your work with gold leaf. First, cover the sections where you want to apply the gold leaf using gilding size. The gilding size must dry for about 20 minutes before you can apply the metal flakes. When the time comes, apply the pieces of foil leaf smoothly with the help of a brush or pinchers and press them down slightly with a brush. Let everything dry well before proceeding to the next step.

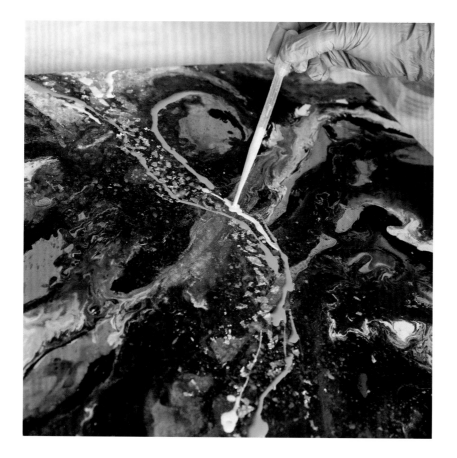

4 Finally, add light green and cobalt blue to separate containers and mix the paints with water. Then apply the diluted colors to the edges of the gold leaf with a pipette and spray them with water. If you want, you can apply a glossy finishing varnish once everything is dry.

TIP: If too much water has accumulated on the painting, lightly dip a sheet of paper towel into the wet surface. It will draw out the excess water wonderfully.

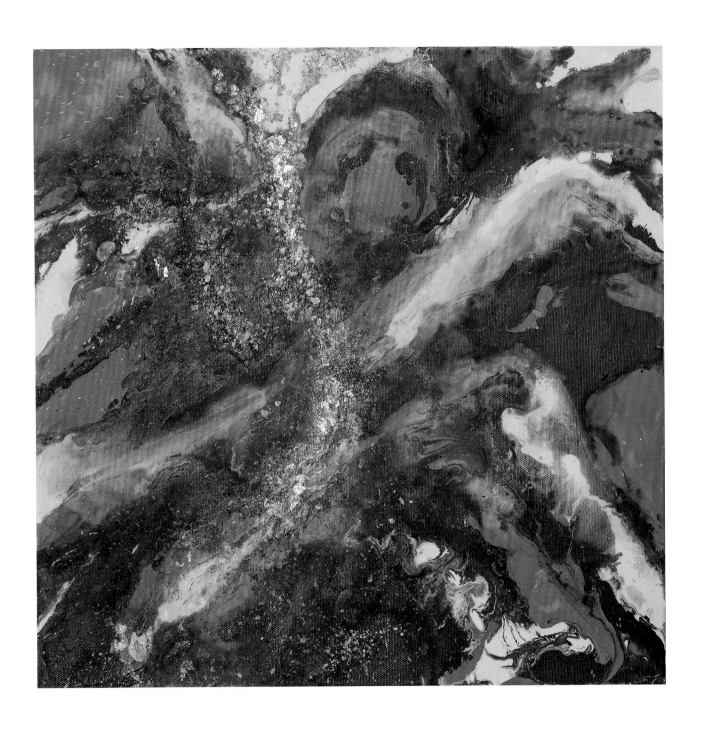

FAIRY GARDEN

PICTURESQUE COLOR PLAY

MATERIAL

Stretched canvas or
canvas board
30″ × 30″ (80 × 80 cm)

COLORS

Pastel yellow, sand,
white, fern, light
green, green earth,
sap green, primary
magenta

Set of foam rollers,
paper plates, and
brushes for mixing
colors

The fairy garden, with its pastel colors, is dominated by calm and serenity. It evokes the sense of an enchanted landscape lying in the haze of a spring morning. It doesn't appear dull at all: Dynamism is created by the horizontal strokes.

TECHNIQUE

In this painting, several layers of paint are applied on top of one another using a foam roller. Because acrylic paint dries so quickly, it is well-suited for this layering technique. By superimposing layers of paint, the surface becomes textured, and a sense of depth is created. Color variation occurs by applying paint both opaquely and transparently.

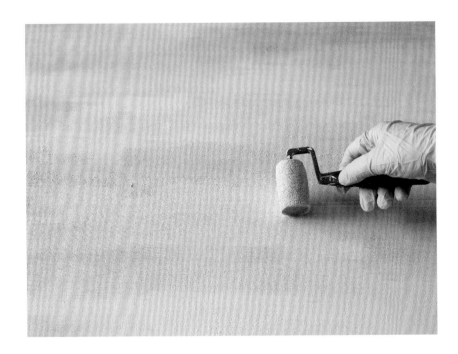

1 First, apply the pastel yellow paint to a paper plate. Then, roll over the plate with a foam roller until the roller is covered with paint. Apply the paint at irregular intervals across the canvas. The *impasto* technique gives the painting texture right from the start. Continue with the sand color, applying it next to the pastel yellow so that the lines cross and the colors blend a bit. Next, apply the fern color in short horizontal lines.

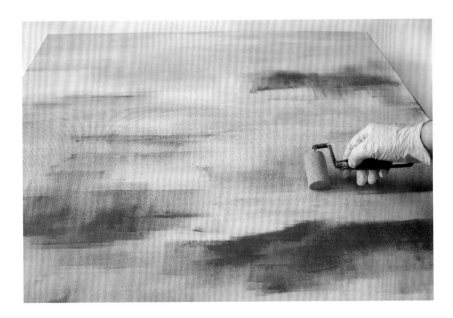

2 Prepare a light gray tone on a second paper plate for the next coating. Mix white with a little black. Use the roller to roll the light gray color over the lower section of the canvas and a little on the right side. Press the roller a little more lightly to achieve transparent areas of color, and a little stronger to create opacity. Then, using a brush, mix white with a little green earth color on another paper plate. Use the foam roller to set light green accents on your canvas.

TIP: It is best to use several foam rollers. This makes it easier for you to work and you don't have to wash out the roller immediately after each coat of paint.

3 Now continue with stronger colors. Put the green earth color on a paper plate. Use a lot of it to cover the foam roller and then roll over the lower and right halves of the picture. Only emphasize the left side of the image a little. Repeat the process with magenta and roll it over the lower section of the canvas. Apply all the colors in a horizontal direction.

4 The addition of different colors creates interesting gradients and mixed tones. The design already appears somehow veiled, an effect you can enhance in this step. Use the roller with white and pastel yellow to paint over the canvas, opaque in some places and transparent in others. The colors now appear even more diffused. Finally, emphasize some lighter areas in the picture using magenta. Distribute the paint with light pressure to emphasize contrasting colors.

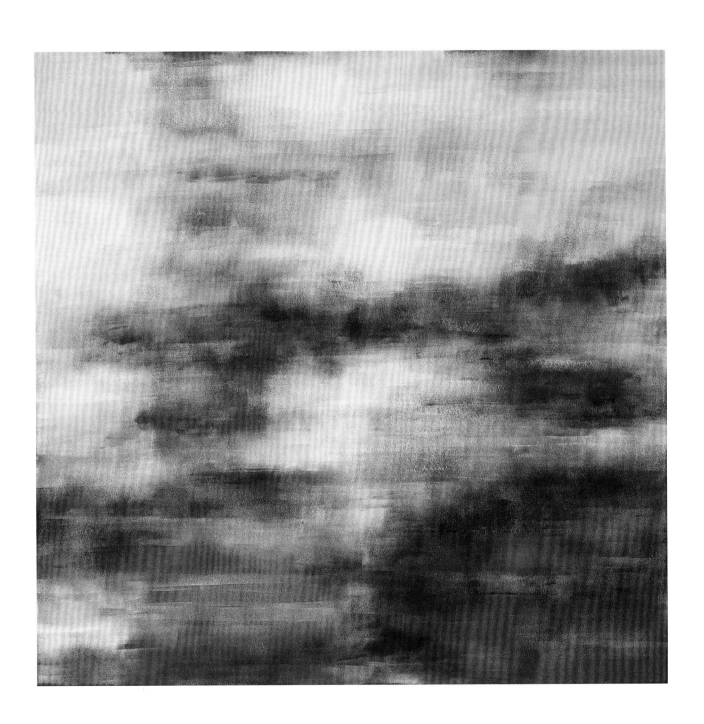

INTERPLAY

THE ALLURE OF CHANGE

MATERIAL

Stretched canvas or
canvas board
20″ × 28″ (50 × 70 cm)

COLORS

Quinacridone
magenta, sand, primary
magenta, dark madder,
turquoise, bordeaux,
white, lilac, and light
green

BRUSH

Flat brush size 24

Painting palette or
paper plate, foam
roller, corrugated
cardboard, and color
shaper size 1.5

In this abstract composition, the light and dark contrasts create a depth that appears mysterious. In contrast, the free forms, vibrant surfaces, and pulsating colors convey a joyful mood— like a new beginning or a departure into a new adventure.

TECHNIQUE

In this abstract composition, you create structures on differently-colored surfaces with the help of corrugated cardboard. The resulting lines give your work a sense of rhythm and movement. Then, you add new layers of color on top of each other, resulting in an impression of a moving, shimmering interplay of colors.

1 First, create different colored sections on your canvas. Start with bordeaux, dark madder, and magenta, painting the top right and center left areas. Then, paint the upper and lower areas with light green. Create more areas with turquoise, sand, and lilac, blending the colors into each other. Keep washing out your brush to ensure clean color transitions.

TIP: Always let the individual layers of color dry well before applying the next layer. This way you avoid unpleasant color mixing.

2 Take a piece of corrugated cardboard and use bordeaux and magenta to paint it opaque without water. Place the painted corrugated cardboard face down on the top right and in the middle and left areas of your canvas and press it down. The cardboard creates an imprint of parallel lines.

Using a foam roller and the light green paint, create a larger colored area in the bottom right corner of the painting. Spread some of the paint over the large areas you created using bordeaux. Draw a few longer and shorter lines with the edge of the foam roller. Then, using a clean foam roller, dab turquoise on the bottom of the painting and draw several lines with the edge of the roller from the bottom right diagonally to the upper left corner.

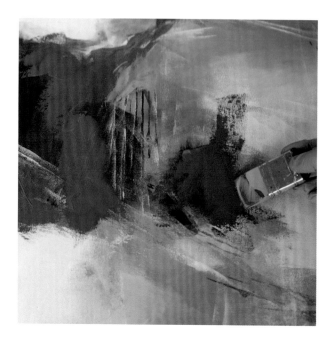

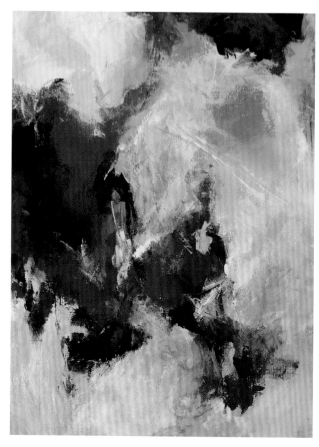

3 Now work from dark to light, being sure that whatever color you are applying is lighter than the one underneath it. First, pick up the primary magenta paint with the color shaper and apply it opaquely to the left, burgundy-colored area. Extend the area by smudging the edges of the color and paint in a few new, small areas. Apply the paint irregularly, so that the underlying layer is still visible in some areas. Spread the magenta to the lower right corner. Repeat the same process in the upper right corner of the painting.

Then, take the sand color with the shaper and paint large parts of the light green areas in the picture using the same technique. Spread the paint so that the color underneath still shines through in places.

4 When all the layers are dry, mix turquoise with water on a paper plate and apply it transparently with the shaper. Spread the paint in the middle of the picture and in the lower section. Use the tip of the shaper to distort the color so that small, curved lines are created. Repeat the same with the white, sometimes making it a little opaque, sometimes a little more transparent.

Finally, apply an opaque layer of color in light pink, mixed with white and a little magenta. Apply the color to the upper and lower bordeaux-magenta areas with a shaper. Then, connect both areas with a slightly wider line. Make the color a bit more transparent as you move toward the lower right corner of the image. Add some more of the color to the upper part of the image and smudge it slightly at the edges. If you like, use the shaper to add a few more accents with lines or blobs of white and light green.

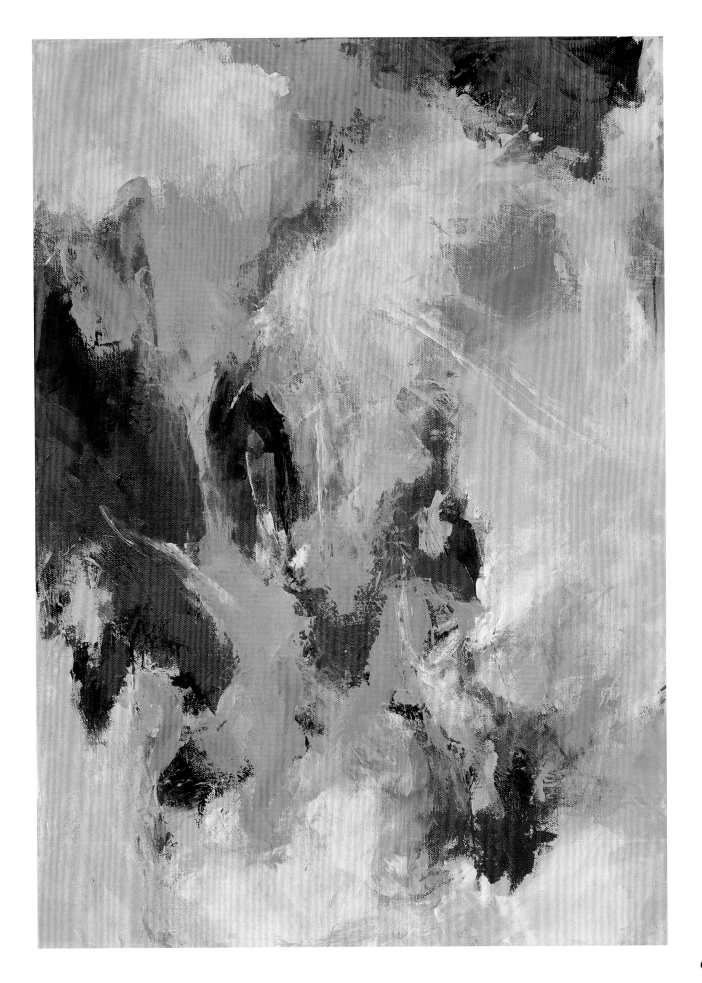

GEOMETRY SQUARED

EXPERIMENTING WITH LINES

MATERIAL

3 Stretched canvases
or canvas boards
12″ × 12″ × 2″
(30 × 30 × 4.5 cm)

COLORS

Cadmium red,
orange, black, and
white

BRUSHES

Synthetic flat brush
size 10, bristle brush

Palette knife, black
putty or black paint,
painter's tape, sand,
painting palette, and
steel wool

This triptych takes its inspiration from the Erasmus Bridge in Rotterdam. The impressive steel cable construction with the towering white pylon is a landmark of the Dutch port city. The black and red lines in the picture symbolize the cables of the suspension bridge.

TECHNIQUE

In this painting, all layers are designed with a rough surface. This creates different textures. Each layer must be dry before the next one is applied. The process of creating lines opens experimental design possibilities.

1 Dab a few blobs of cadmium red and orange directly onto your canvas. Spread the colors with a wide palette knife and mix them together. Also, work on the sides of the canvas frame.
Sprinkle some sand into the wet paint and spread both with the knife. By doing this, you create rough tracks on the surface of the painting. Let the canvas dry well.

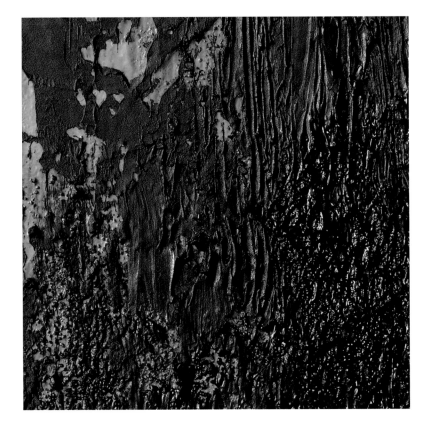

2 Using a palette knife, take up the black putty and spread it on the canvas. Let the underlying color peek through in some places. Scratch a few lines into the still-wet area with steel wool. Apply the putty to the edges of the canvas as well. Let your work dry.

TIP: Work on all three pictures at the same time. You can place the suspension bridge's cables at different distances.

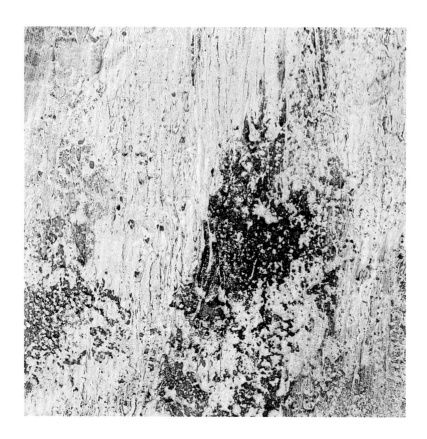

3 Put white paint on a palette and use a flat brush to spread it across part of the surface of your canvas. Apply the paint opaquely and granulate it at the edges. To do this, take up very little paint with a bristle brush and rub the brush lightly over the surface of the painting. Again, let everything dry well.

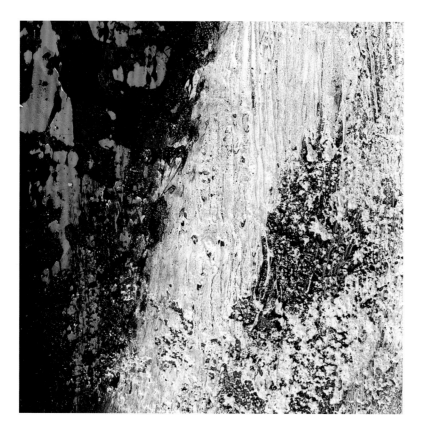

4 To create the two lines in the painting, you will need painter's tape. Measure the required distances with a ruler and then press on the tape. Start with the straight red line. Press the tape firmly so that no paint will run underneath. Spread red paint between the two strips using a smaller palette knife. Once the paint has dried a bit, carefully remove the tape. Wait for the paint to dry completely and finish by painting the black line in the same way.

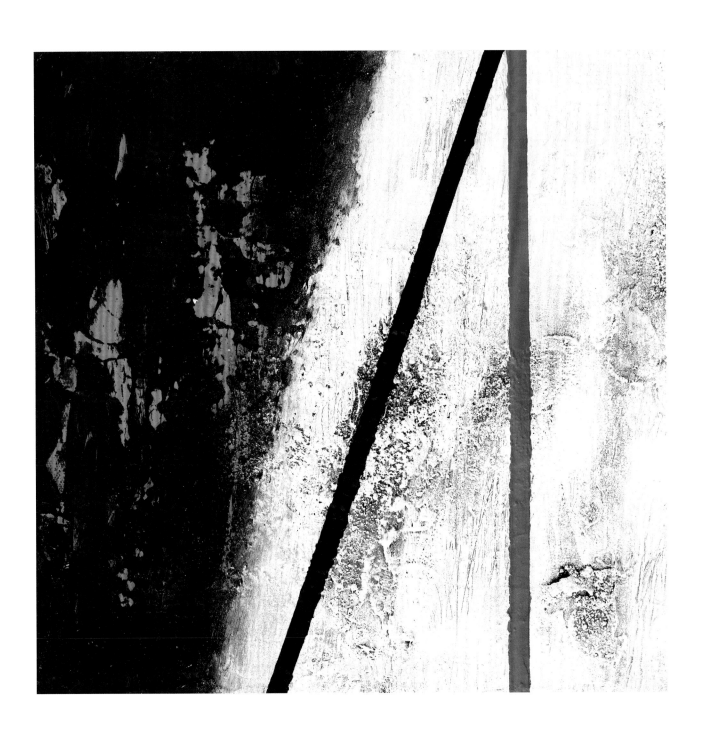

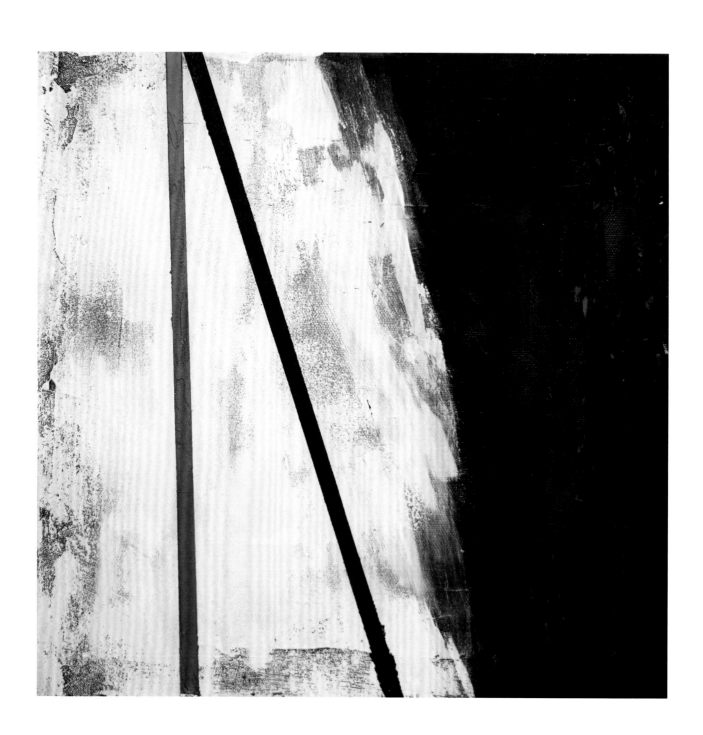

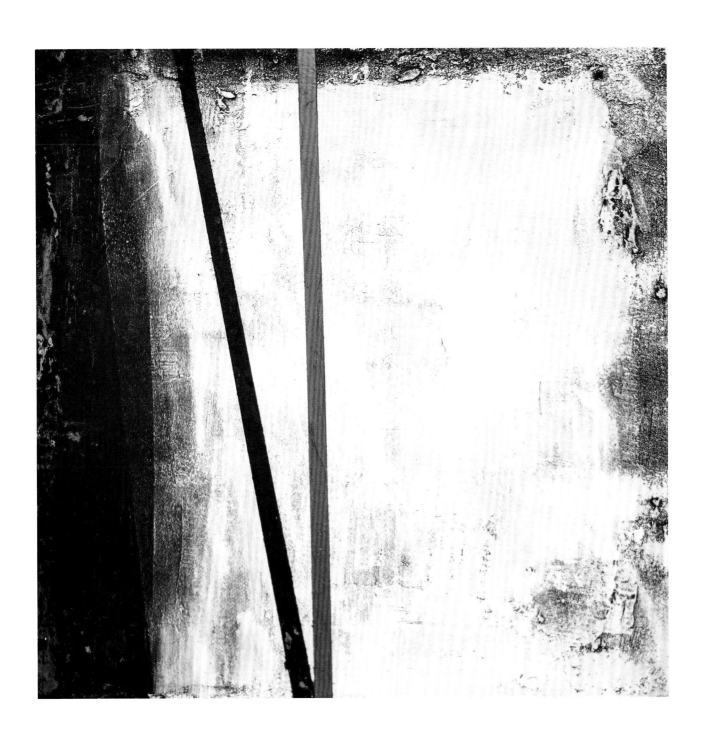

BRIEF ENCOUNTERS

LIGHT AND AIRY COLOR FANTASY

MATERIAL

Stretched canvas or
canvas board
20″ × 28″ (50 × 70 cm)

COLORS

Fern, white, phthalo
blue, and aquamarine

BRUSH

Flat brush size 30

Color shaper size 2,
acrylic binder, acrylic
painting medium,
foam roller, paper
plates, and small
containers

Airy, yet grounded—this abstract composition might remind you of a tree with its roots and branches. The sun's rays stream through the branches, making them shine. Colors and contrast disperse and condense in a dynamic balance.

TECHNIQUE

I call this technique Shaping. The paint is poured onto the canvas and shaped with the color shaper, a wide rubber brush. The painting is constructed from several layers of color. Each layer is coated with the acrylic binder before a new layer is started. These layers make the thinned acrylic paints easier to work on the surface without losing their color intensity. After drying, all painted layers are solid.

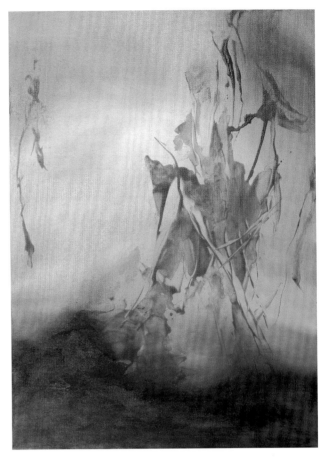

1 Prime your canvas using a wide flat brush and the colors fern, white, phthalo blue, and aquamarine. To get smooth color transitions, paint directly on the canvas. Work on small areas and paint them until the layers of color combine harmoniously to create soft color gradients. This is important because you need a serene background for the subsequent design. When everything has dried well, pour acrylic binder onto a paper plate, take it up with a foam roller and roll it over the entire canvas.

2 The layer of acrylic binder will make your canvas surface slightly sticky, smooth, and shiny. Now when you pour your colors over it, they will be easy to shape with the shaper while keeping their color intensity. In a container, mix a little aquamarine with water. Since aquamarine is transparent and very pigmented, you only need to add a little water. Pour the paint over the right side of the canvas. Then, shape the poured color with the color shaper by working out fine lines and areas. Once this layer of paint is dry, apply a new layer of acrylic binder with the roller.

TIP: Work with a color shaper that has a flat, flexible tip. This is especially good for drawing thin lines.

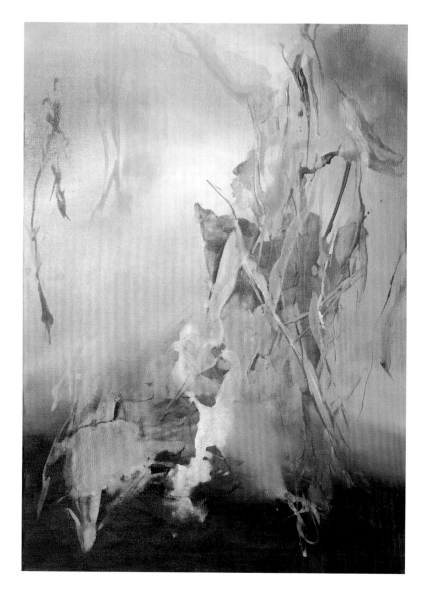

4 Before you carry out the last step, use your painting medium. Mix aquamarine, phthalo blue and white with the acrylic painting medium and a little water in a container. The painting medium intensifies the glaze and gloss effect. Let the paints flow over the canvas one after the other, pouring them from top to bottom over your painting. Finally, draw a few white lines with the shaper.

3 Mix the fern and white colors together with water in a container. Pour your diluted fern onto the canvas and use the shaper to form new lines and areas. Then, pick up diluted white paint with the tip of the shaper and draw contours in the fern-colored areas. Spray the colors lightly with water so that they flow into each other a little. Now, let your canvas dry again. Then, apply several new layers of acrylic binder with the roller as an intermediate varnish.

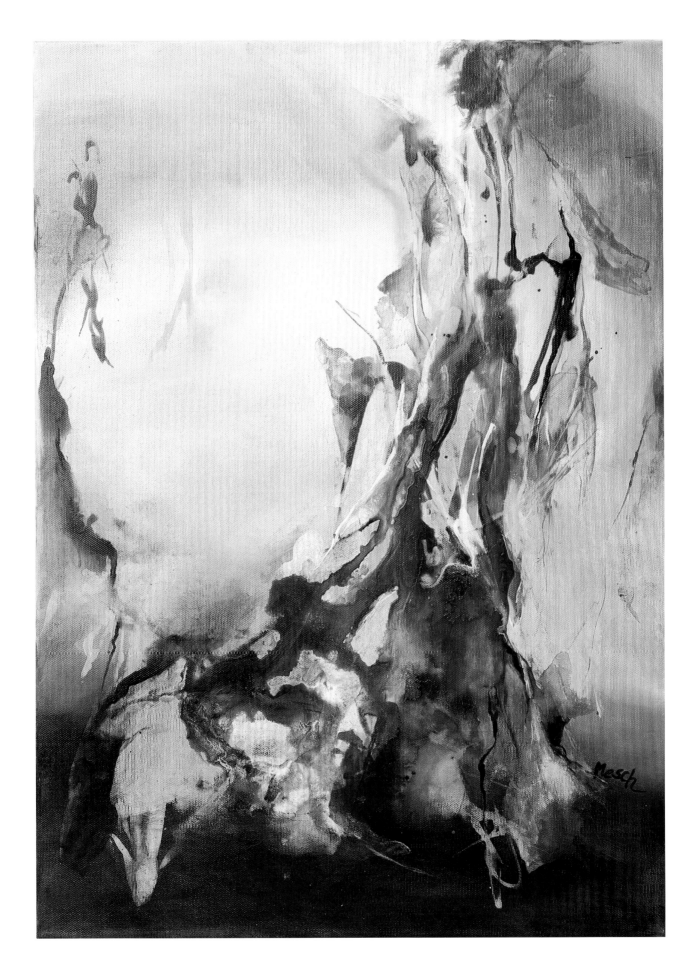

TIMELESS
INSPIRATION DRAWN FROM MEMORY

MATERIAL

Stretched canvas or
canvas board
20″ × 20″ (50 × 50 cm)

COLORS

White and black

BRUSH

Spalter brush size 20

Metallic gold acrylic
spray, marble powder,
acrylic binder, ash,
palette knife, marble
effect spray in black
and white, paper
plate, and varnish

Do you sometimes lack picture ideas? Your own memories and emotions can be a valuable source of inspiration. This painting is a reminder of my favorite city, where modernity and tradition meet at every corner. This contrast is symbolized by the shiny gold offset by the other materials used. Look closely: maybe you can make out houses, electrical towers, and palm trees?

TECHNIQUE

After the background is created using the dripping technique, the painting is then partially covered with putty. With this technique, the background is integrated into the image. The upper layer is applied in such a way that the underlying layer remains clearly visible in some places. This causes beautiful contrast effects. This technique can also be used if you have old paintings you want to paint over.

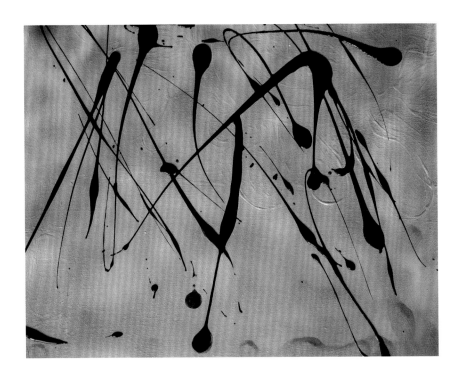

1 To prime your canvas, spray it entirely with metallic gold acrylic spray. The metallic gold dries very quickly, so you can continue working after just a few minutes.

Lay your canvas on a sheet spread out on the floor. Now, drop and pour the black paint with quick movements directly from the bottle onto the canvas. Liquid acrylic paint from a bottle is best-suited when employing this dripping technique. You can also add a little beige to your black paint and then drizzle it over the canvas with the end of a brush handle.

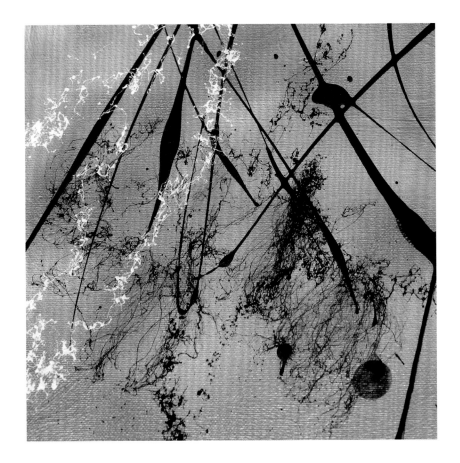

2 Now, spray the marble effect spray onto the canvas using a gentle waving motion. This does not create a spray mist, but ejects thin threads. On the surface, they create loose webs of thread. The greater the distance to your canvas, the finer the threads will be. It doesn't matter what color you start with. Spread the fine fibers all over the canvas.

TIP: Instead of metallic gold acrylic spray, you can also use gold acrylic paint. Make sure that the background is well-painted and opaque.

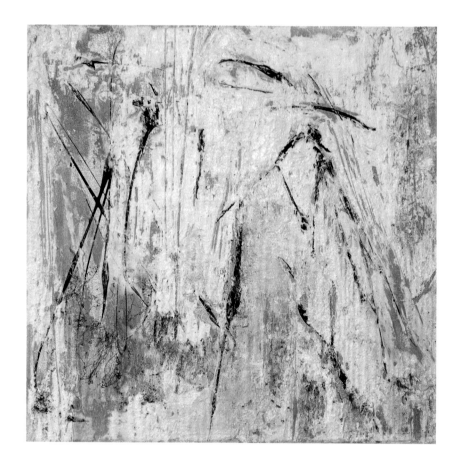

3 On a paper plate, add two-thirds marble powder to one-third acrylic binder. Mix until a homogenous putty is formed. Apply the putty to the canvas a little unevenly using a palette knife. Do not cover the entire canvas, but let the left side of the image show through a little more. This way you integrate the background into the pictures. Now, mix as much ash as needed into the homemade putty until it forms a gray mass. Apply this mass to several places in the painting, then scrape off a little putty in the places where the black lines are drawn. Draw a few additional lines with the tip of the palette knife and let the gold of the primer show through again. The painting now needs to dry.

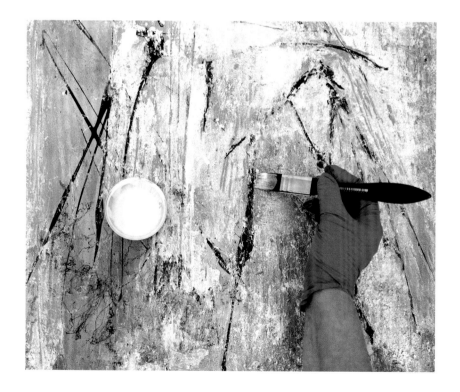

4 In the final step, use a Spalter brush to paint the putty with diluted white color. This creates a harmonious overall impression. Finally, spray your work with varnish to protect it from dust and moisture.

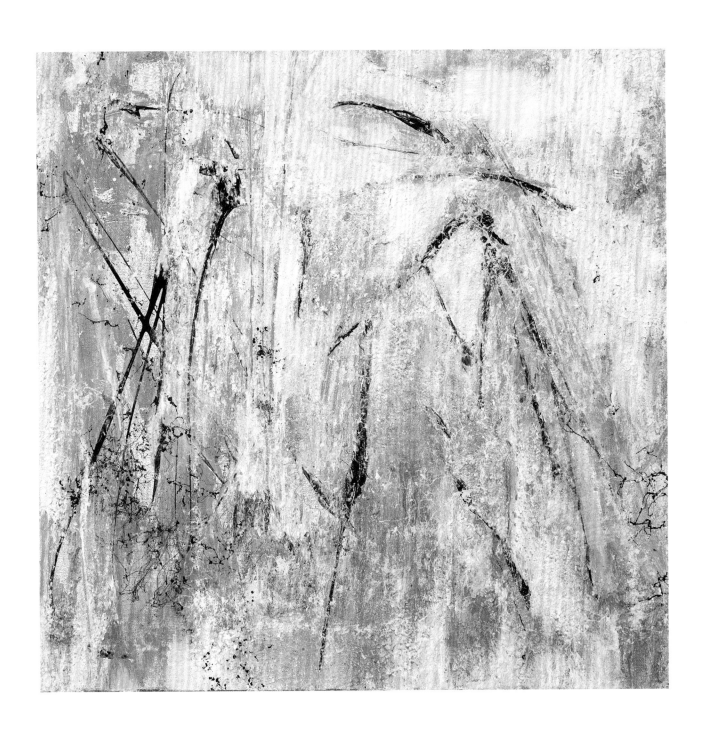

SHIFT CHANGE

DANCING COLOR TONES

MATERIAL

Stretched canvas or
canvas board
24″ × 30″ (60 × 80 cm)

COLORS

Turquoise, raw sienna,
olive green, sand,
white, and black

BRUSHES

Spalter brushes sizes
1 and 2.5 as well as
synthetic brush size 6

Color shaper size 1.5,
palette knife, acrylic
painting medium,
small containers,
painting palette, and
spray bottle

In this painting, everything is in motion. The two black fields facing each other dance around the central axis. Other pictorial elements emerge from the depths of space, resonating together, but not uniting. A network of equivalent lines and fields of color support the dancing dynamic feel.

TECHNIQUE

After the background is laid out, the paints are applied transparently in several glazing layers. By using the glazing technique, the layers of color mix with one another and create brilliance and depth in the painting. The spontaneous lines and contrasts soften and fade into the background.

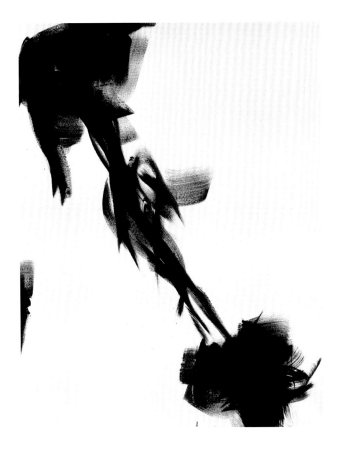

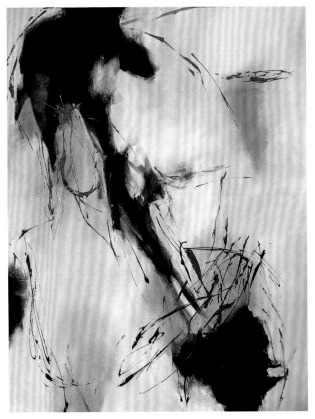

1 Using the large Spalter brush and a loose, generous brush stroke, distribute the black paint in the upper left and lower right areas of the image. Join the two areas together. Paint another smaller black area on the left edge of the image.

2 Pour white, sand, and raw sienna onto a painting palette. Using the size 1 Spalter brush, apply the paints solidly to the areas of the background that are still color-free. Spread some turquoise into the still wet color and blend it with the background color. Let the paint dry well.

In a small container, mix a little black paint with painting medium and water. Dilute the mixture until you get a runny consistency. To bring dynamism to the painting, draw moving lines with the liquid color using a small palette knife. Then, let everything dry well.

TIP: If you want to paint colors into each other, both colors must still be wet. Do not use too much paint on the brush. Paint with short brush strokes on one area until you get a smooth color transition.

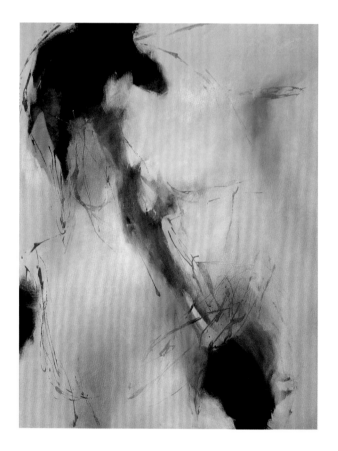

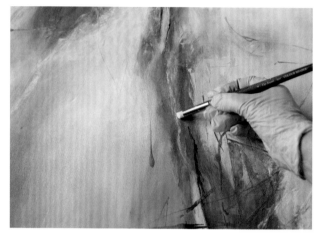

4 Color the next glaze olive green. Apply the thinned color to the turquoise areas and blend them with white. Apply more white glaze to lighten the center of the picture.

Now, emphasize areas with an opaque coat of raw sienna paint. Spread the paint with a palette knife. Blur the edges with water until they become transparent.

Finally, use the color shaper to trace a few existing lines and add new ones.

3 Spray the surface of the canvas lightly with water. Then, using a wet Spalter brush, paint the background with transparent white, sand, raw sienna, and turquoise. Pick up only a small amount of paint with the brush. Only partially paint over the black areas. For the first layer of paint, the glazes should be applied very thinly so that the color effect can be built up in the next layer. Now let your painting dry.

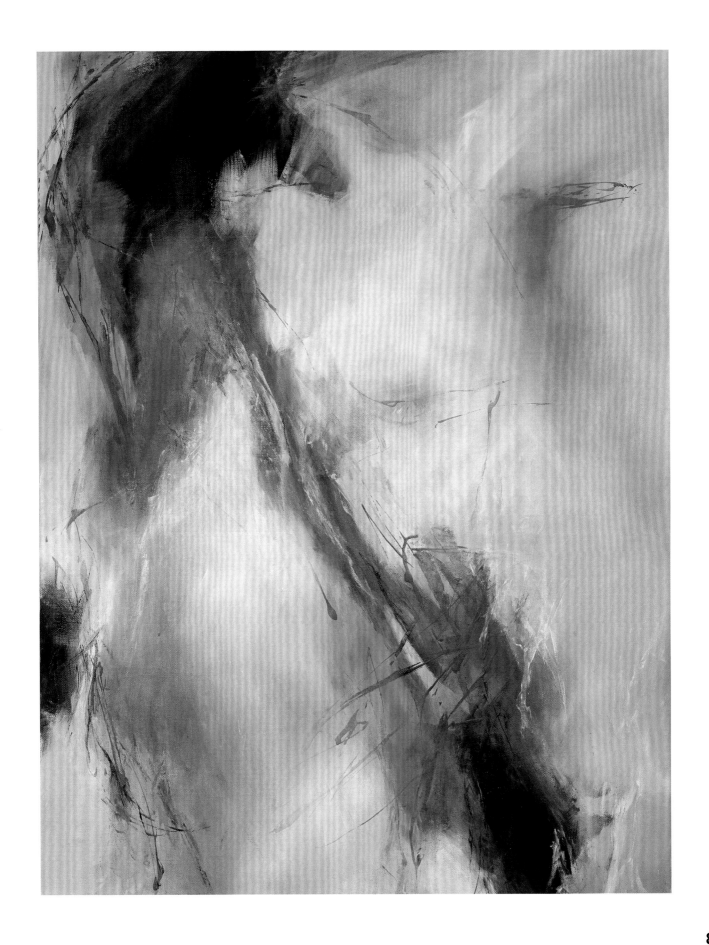

SPLASH!

SPLASHES OF COLOR ON A SEASCAPE

MATERIAL

Stretched canvas or
canvas board
20˝ × 40˝ (50 × 100 cm)

COLORS

Indigo, copper,
turquoise, white,
phthalo green, steel
blue, and dark cobalt
blue

Putty, sand, palette
knife, fork, bristle brush,
spray bottle with water,
spray brush, container,
and paper plate

Seascapes are forever fascinating. The unfathomable shimmering turquoise blue, the white foaming spray, the moving waves. It is not difficult to depict all of this. All you need are different types of glazes applied on top of each other. With each glaze, you increase the transparency of your image and capture the sun reflecting light on the waves. The white splash of color at the end makes your sea picture-perfect.

TECHNIQUE

By sprinkling sand and scratching the putty the background takes on a rough, animated impression. By superimposing semi-transparent and glazed layers, you create vastly different color impressions. On the one hand, this makes your picture even more interesting, and on the other, it reinforces the three-dimensional impression. Pouring the white paint is the icing on the cake.

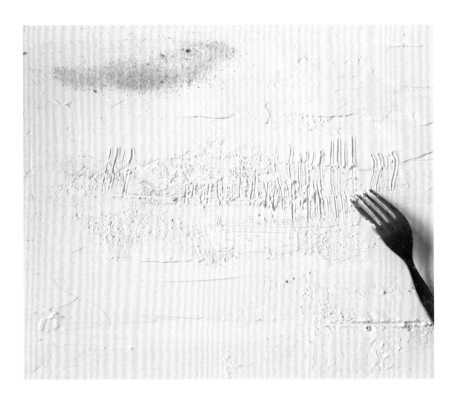

1 Apply the putty to the entire canvas. Sprinkle sand in some places and mix it with the putty. Scratch several horizontal and vertical lines into the still-wet putty with the tip of the palette knife and a fork. This creates textured effects. When the putty has dried well, paint the entire canvas with indigo. Then, pick up copper with a bristle brush and paint several wide, diagonal lines and areas in the center of the image. Allow the paint to dry.

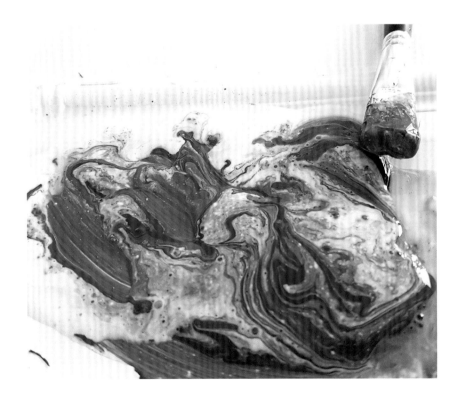

2 Next, on a paper plate, mix steel blue and cobalt blue with a painting medium or acrylic binder. Using a bristle brush to apply the semi-transparent paint, cover the entire canvas. Do not cover the edge or the center of the picture where you applied the copper.

TIP: A glaze is only successful if the bottom layer of paint is absolutely dry. Otherwise, the colors will mix and stain. Allow each glaze to dry before applying the next.

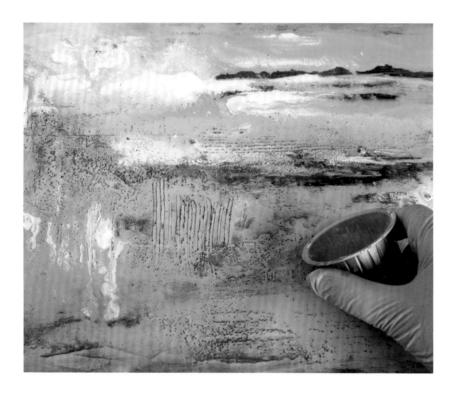

3 After the painting has dried, use separate cups to mix turquoise, white, and a little phthalo green with water and paint medium. Pour the turquoise and white onto the canvas one after the other, moving horizontally. Distribute a few drops of phthalo green in the right and middle sections of the canvas. Spray the whole painting with water. Now, lift the canvas and tilt it from right to left and let the colors flow. Fill the gaps using a palette knife and the diluted paint. Lay the canvas down so that it can dry.

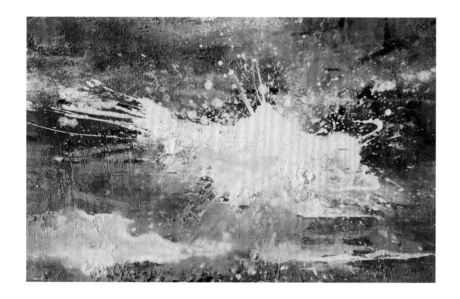

4 Mix white with a painting medium and water in a cup. To avoid dirtying the floor, place a sheet under your canvas. Tip the white paint from above onto the right side of the painting, creating a white splatter. Finally, mix turquoise with water in a container until it is very transparent. Then, pour the mixture over the bottom of the canvas and a little more on the splatter. Paint the transparent glaze all the way to the edge of the canvas.

TIP: For a large, effective splatter, hold the paint high above the canvas and pour from there. You can stand on a ladder to do this.

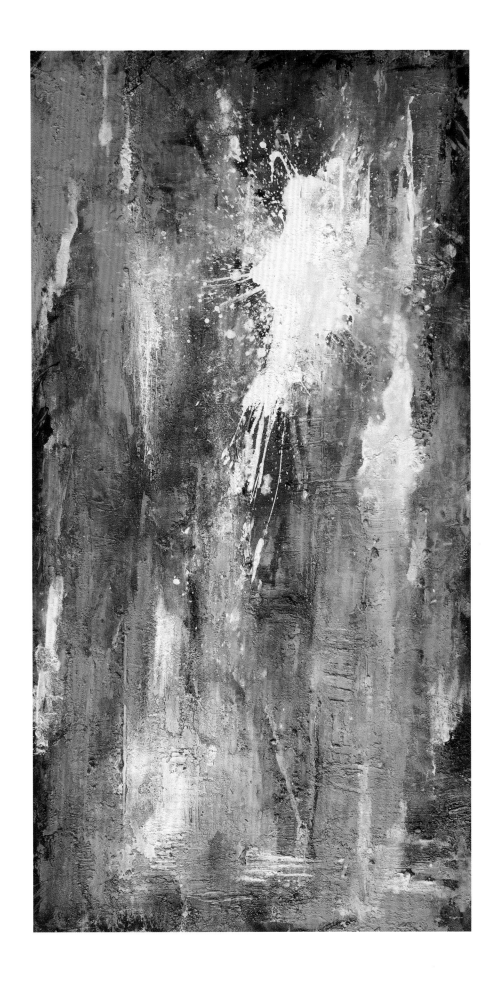

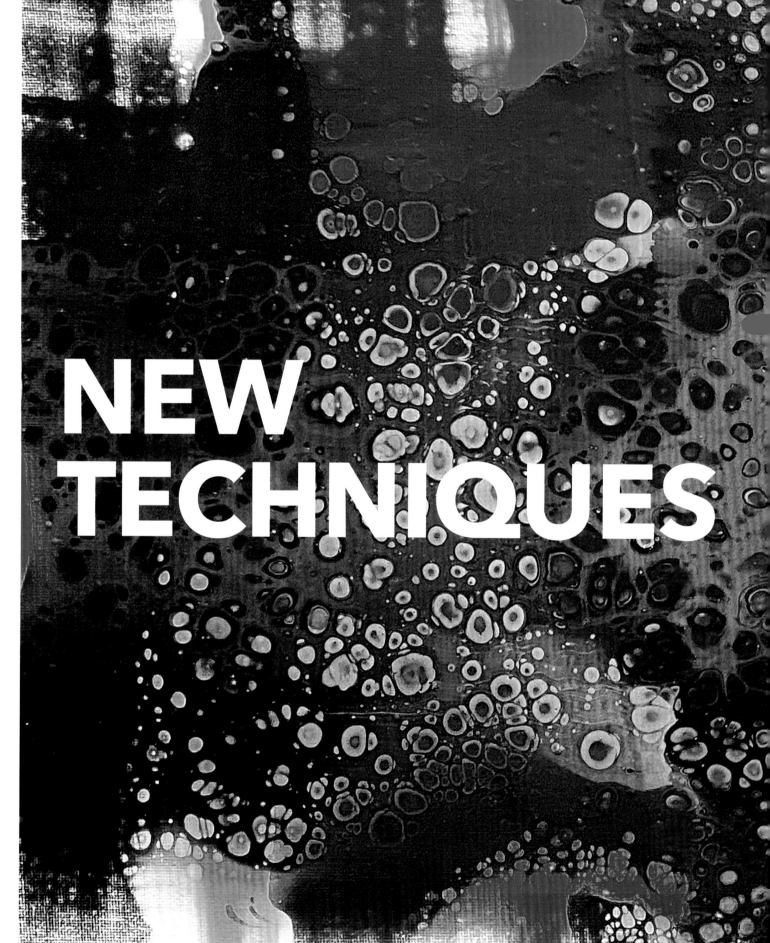

NEW
TECHNIQUES

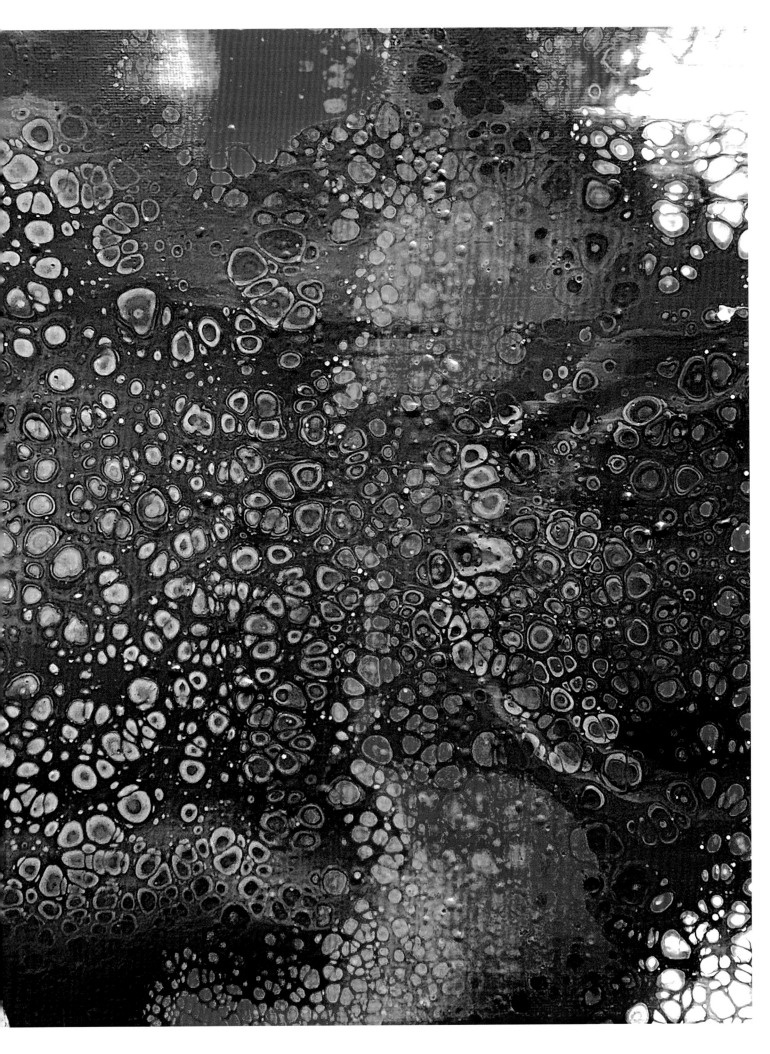

PLAYING WITH COLORS

DOUBLE FLIP CUP

MATERIAL

Stretched canvas or canvas board 6″ × 8″ (13 × 18 cm)

COLORS

Permanent blue violet, yellow, orange, cerulean blue, turquoise, and titanium white

Pouring medium, small cups for mixing paint, distilled water, paint stirring sticks, flambé torch or heat gun, old clothing, latex gloves, drop sheet, drip pan if required, and silicone oil

If you were to give acrylic pouring a motto, it would be: experimental and abstract. Acrylic pouring is a great way to give up control and perfectionism and let the paint take over. You can try it out right now: In the following pages, you'll see two cool variations on the same theme. The number of elements building up the design of your poured painting can't be planned, and it makes each painting a grab-bag of surprise and wonder.

TECHNIQUE

When using the pouring technique, it is important to make the acrylic paint fluid while retaining the properties of the acrylic paint. Therefore, make sure to use a high-quality pouring agent. Because of the different weights of the pigments, ideally both small and large cells will form. This means that different colored ovals and circles within the cell structure will appear on your poured image, under which the underlying color layer will be revealed.

The unique patterns and special color effects are especially suitable for beginners. Using the flip cup method, you first layer all the paint in a cup. Then, place the cup upside down on your canvas and lift it. The paints spread out by themselves, and the result is always fascinating.

1 Start by mixing your pouring blend. You will need acrylic paint, pouring medium, distilled water, and silicone oil. Mix all five colors separately in their own cups. Mix each paint in a 1:1 ratio with your pouring medium. The consistency of the mixture should resemble liquid honey and flow off your stir stick without issue. If it does not, add more pouring medium and/or distilled water until you reach the desired consistency. Add two to three drops or squirts of silicone oil to each side of the cup and stir briefly.

2 Now take two fresh containers and layer your colors on top of each other in any order. Both paintings should look similar, but not the same. That's why you vary the order in which you layer the colors. Rest your two canvases on top of two empty cups resting on the sheet you have laid out. Make sure they do not touch the floor.

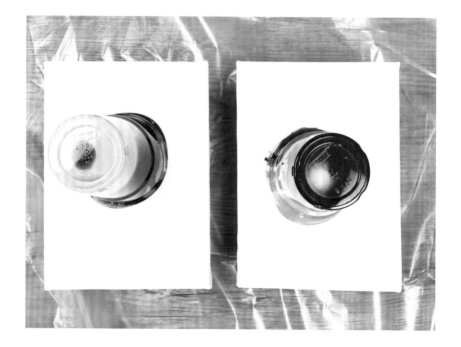

3 Pick up your first canvas and place it face down on the first cup and turn everything over. The cup should be centered on your canvas. Place the canvas back on top of the empty cups so it doesn't touch the ground. Do the same with your second canvas. Now wait about five to ten seconds until you lift the cups of paint. If you have not yet done so, put on your disposable gloves.

TIP: Silicone oil is available in drops or in a spray bottle. Feel free to try the inexpensive oils as well. High-quality silicone oils do not automatically guarantee more or larger cells.

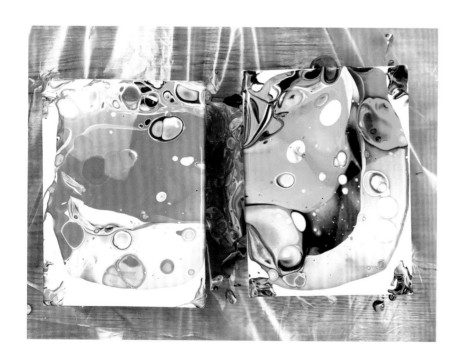

4 As soon as you lift the cup, the paint will spread automatically. Now you can observe the first differences in color and cell formation.

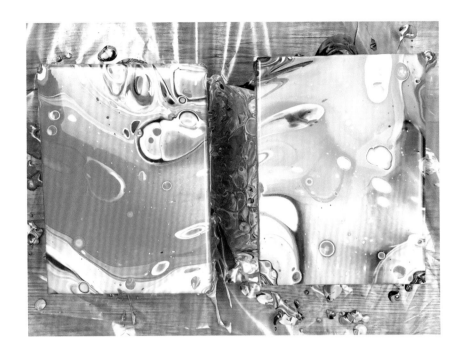

5 Gently tilt your canvas to let the paint flow over all the open areas. Also, place smaller dabs of color in the corners so that they don't remain blank.

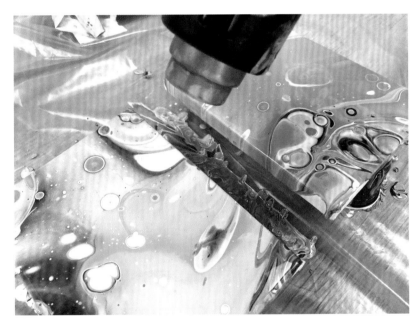

6 Now things get exciting again: Use a heat gun or flambé torch to briefly expose the paint surface to heat. Short means about three seconds with the movement of your hand. The heat usually causes even more cells to open up and allows the lower layers to come out. On the next two pages you'll see the fascinating results.

Let your painting dry thoroughly for at least two days. For a complete hardening it might even take three to four days. Afterward, you can seal your painting with acrylic paint or casting resin.

TIP: As an alternative to acrylic paint, you can also use liquid acrylic ink for your pouring pictures. Highly pigmented, acrylic inks are much more intense than metallic acrylic paint and give your picture an absolutely classy look.

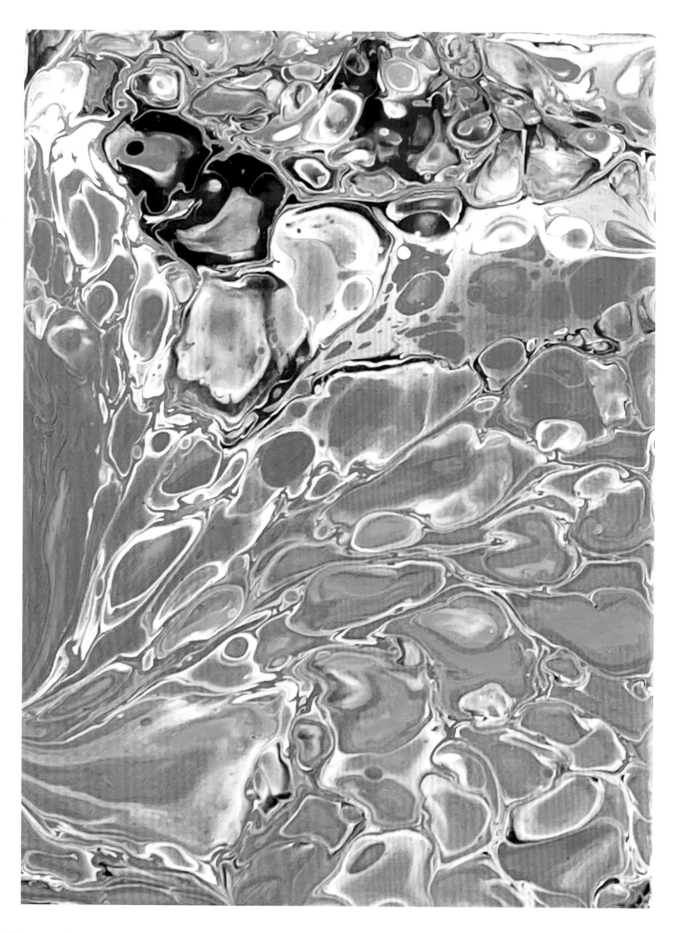

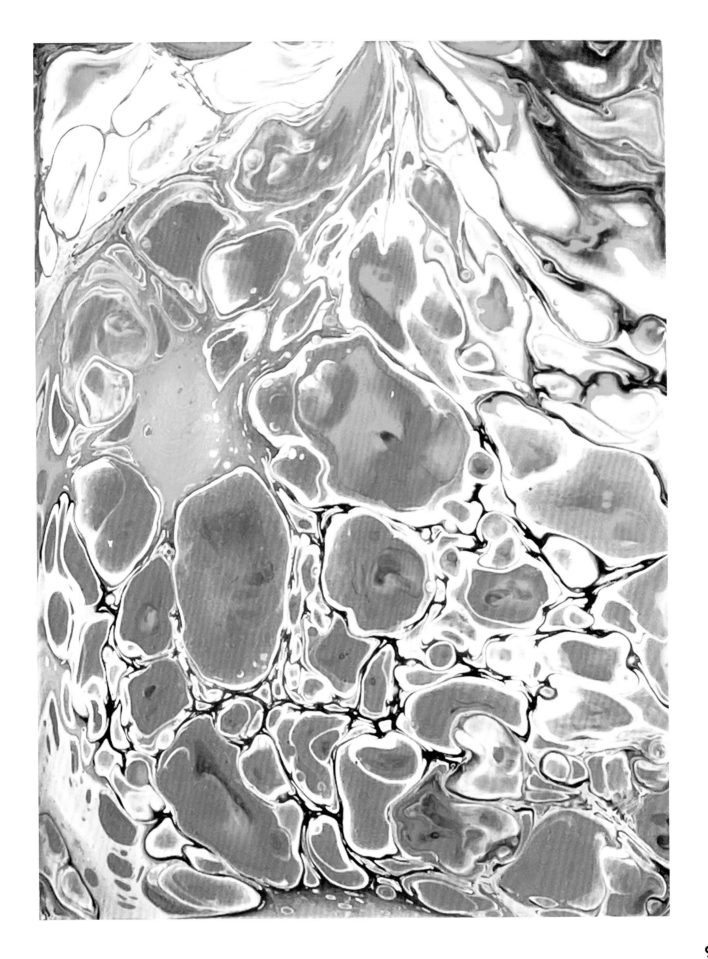

NEON SWIPE

STRIPING FOR GREAT COLOR EFFECTS

MATERIAL

Stretched canvas
12″ × 28″ (30 × 70 cm)

COLORS

Oxide black, Prussian blue, neon orange, neon red, and titanium white

Pouring medium, container for mixing paint, paint stirring stick, flambé torch or heat gun, old clothes, latex gloves, dropcloth, drip pan if required, and a piece of cardboard with a straight edge (at least as wide as your canvas)

We'll stick with acrylic pouring, but now things become a little more challenging. Unlike the Flip Cup method with its unrestrained formation of cells, you have better control of your results when using the Swipe method. With a little practice and a steady hand, you can control your color gradients more deliberately. Neon colors give the image an incredibly special luminosity.

TECHNIQUE

The Swipe method is a great alternative to the Flip Cup method and gives your image a completely different look. While the Flip Cup is good for beginners, the swipe method requires a bit of practice and an especially steady hand. Practice until you get the result you want.

The short heating time usually reveals even more cells in the paint and gives your poured image a unique look. Some artists like to mix silicone oil into the paint for more cells, as in our example. In my experience, it does indeed create more cells. Others claim that it negatively affects the color quality. Again, you can gauge your own experience and try pouring paintings with and without adding silicone oil.

1 Prepare your workspace for acrylic pouring. Be sure to cover it well with a dropcloth. All materials should be within reach. Combine acrylic paints and pouring agent in a 1:1 ratio and blend well until you get a consistency like liquid honey. If your mixture is still too thick, carefully add distilled water. Divide your paint mixtures into several containers and set them up along the edge of your canvas. For a 12″ × 28″ (30 × 70 cm) canvas, I divided the paint into ten cups. Add two or three drops of silicone oil to each cup and stir once. Keep your piece of cardboard close at hand.

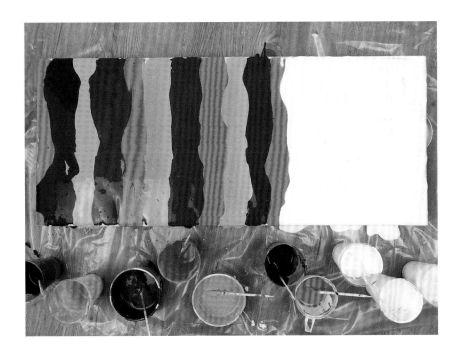

2 Pour the paints onto the canvas in alternating vertical strips. The last third should be completely white. Now, carefully push your paint to the edge of your canvas with a palette knife or a paint stirring stick. The white spaces between the colors should also be covered with paint.

TIP: You should be able to keep your canvas level and balanced on four to five well-placed containers. Alignment is especially important because the poured colors dry extremely slowly and can flow off one side of your canvas with the slightest tilt.

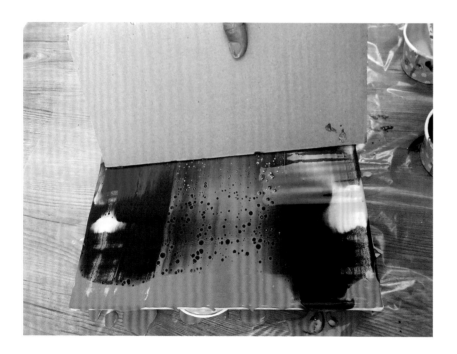

3 Take your piece of cardboard and align it with the straight edge parallel to the shorter edge of the canvas. You will then draw the colored paint stripes toward the white paint. Focus on the surface and pull the cardboard slowly and calmly with even pressure all the way across your canvas. The cardboard should be almost perpendicular to the canvas.

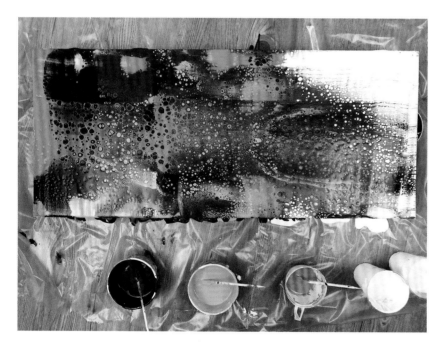

4 Heat the top layer of paint for about five seconds using a heat gun or flambé torch. This will create more cells that will pop open and expose the underlying layer of paint. The darker colors of black and blue make the neon colors shine especially brightly.

TIP: Before working with the swipe technique on a large canvas, try your hand at a smaller canvas first. The correct "swipe" technique and the distance between the canvas and the cardboard need to be practiced, so that too much paint isn't swiped from the painting, but still enough that the paint blurs into the next layer of paint.

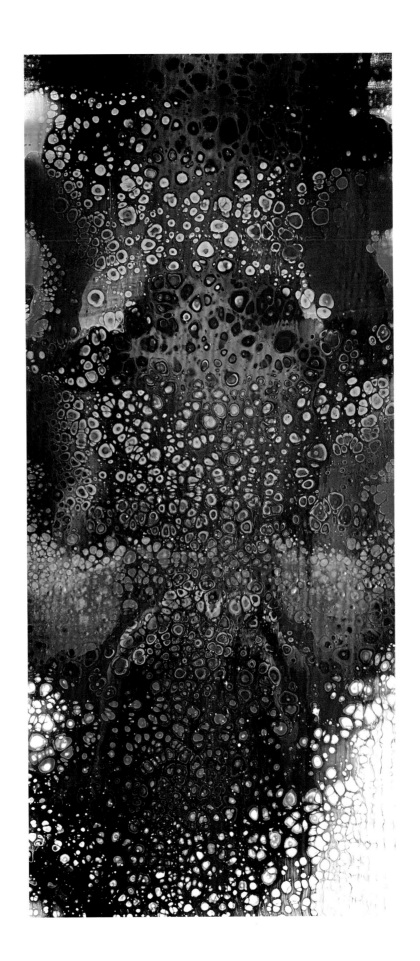

BLOB PAINTING

STRAIGHT TO THE POINT

MATERIAL

Stretched canvas or
canvas board
12″ × 16″ (30 × 40 cm)

COLORS

Titanium white, Indian
yellow, magenta,
turquoise, royal blue,
phthalo blue, black,
light green, dark green

Several bottles with
spouts, containers for
mixing, paint stirring
sticks, vinyl glue,
funnel, and a cotton
fabric painter's roller

The 1970s send their regards: With blob painting, another new trend, you can create pictures with a groovy look and color scheme. Here, color is deliberately placed on top of color. Multicolored, even three-dimensional blobs are created. With this technique, you can experiment indefinitely with your favorite colors or give old, poured pictures a whole new look.

TECHNIQUE

The effect of blob painting comes from the fact that the paint remains stable on the surface and does not run, instead forming an exact circle. You achieve this by adding vinyl glue to the paint. After the blobs are painted onto the canvas, they retain their volume. However, the individual layers of paint require a drying time of at least four to twelve hours at room temperature. Note that many acrylic tones are translucent and you may need to add some titanium white to the mixture.

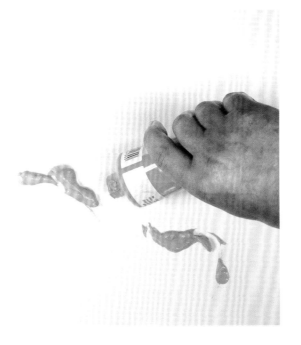

1 First, pour vinyl adhesive into an empty container then add phthalo blue. The ratio of the mixture should be 70 percent adhesive and 30 percent paint. Mix well and then pour your mixture into a bottle with a spout using a small funnel. Do the same with your other colors. Seal your bottles well. Pour Indian yellow directly from the tube onto your canvas and prime it with the paint and a cotton paint roller.

TIP: Mixing the glue and paint can cause air bubbles to form. It is a good idea to let the bottles of mixture sit overnight to allow the air bubbles to work their way out. The mixture remains stable for a long time in the sealed spout bottles.

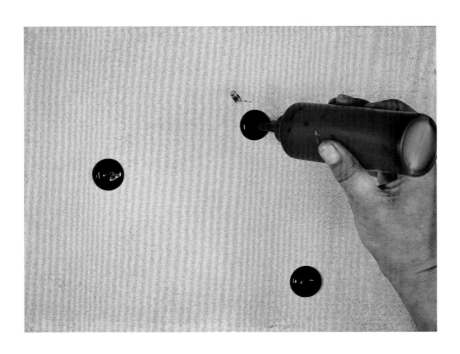

2 Now create the first blobs with black. In order for the paint circles to stay nice and exact, ensure your canvas is lying absolutely flat on the table. Hold your bottle with the spout vertically so that the paint flow starts centrally from the middle.

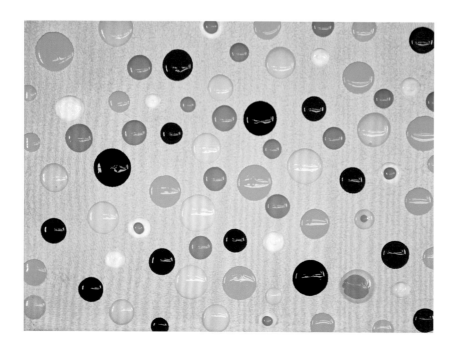

3 Repeat the same procedure with different paint colors. Your canvas will now look as if a small shower of confetti has fallen on it. Before you start on the next layer of blobs, it's important that the blobs on the bottom dry at room temperature for at least four to twelve hours so that they're solid on the surface.

TIP: Drying is really the name of the game with this technique. Please don't get impatient! Blow drying does not speed up the drying phase, but results in unsightly cracks and shriveled effects in the blobs.

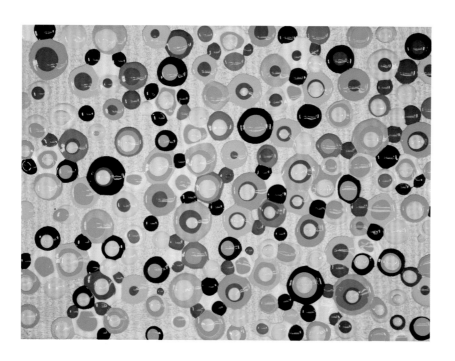

4 If you place the blobs closer together and on top of each other, you will create new shapes and edges, for example honeycomb structures. Now carefully apply more contrasting shades to the center of your blobs. By repeatedly applying new contrasting colors, you slowly create circular, three-dimensional mounds of color. It is precisely the three-dimensionality that makes your painting so interesting, because blob painting is an art technique on canvas or canvas board that we can also feel with our hands. So, in this way haptics is an addition to the visual experience.

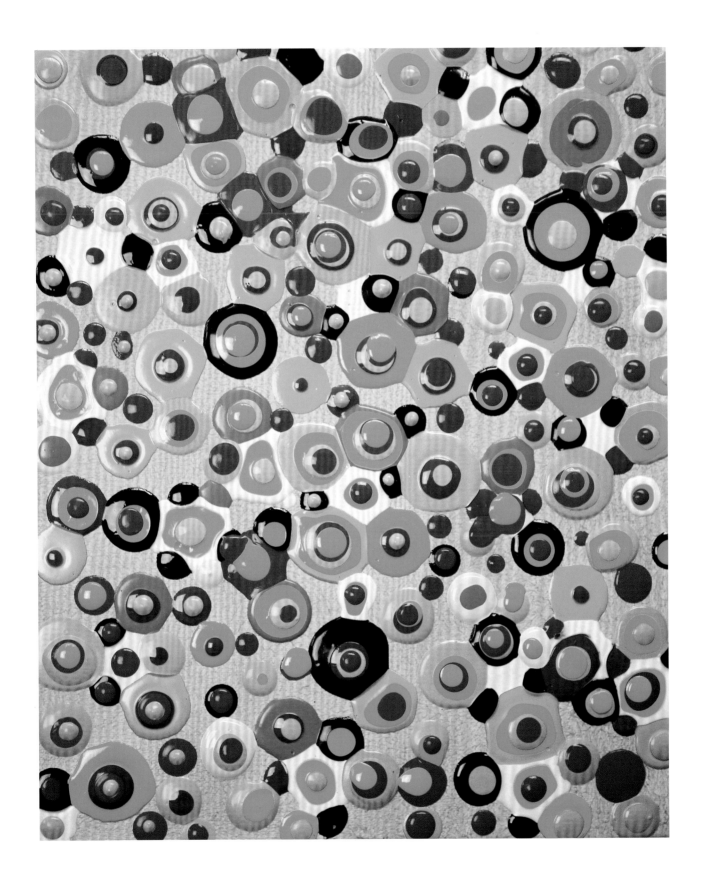

MASTERPIECE IN RESIN

REFINED AND EMBEDDED

MATERIAL

Stretched canvas or
wooden painting
base 16″ × 20″
(40 × 50 cm)

COLORS

Titanium white, light
ocher, and black

Matte black, white
acrylic primer

Acrylic ink in
phthalo green

Liquid shellac,
marble powder, gold
foil, guilding size,
painting knife 12″
(30 cm), resin and
hardener, cloth tape,
hair dryer, mixing
cup, stir sticks, cotton
fabric painting roller,
and vinyl gloves

Creative work with cast resin is actually not that new: In the 1970s, the hobby of pouring all sorts of things into small blocks of cast resin became widespread. Now the material has been rediscovered and further developed for the art world. In contrast to the older casting resins, today's pitches and resins have a high UV stability and remain clear over time after processing. Your finished resin image will therefore look as if cast in glass.

TECHNIQUE

The basic technique of refining with resin is not difficult. However, resins are not meant for children's use since they are two-component plastics. Pay close attention to the mixing ratio with the hardener as different manufacturers may require different ratios. In this painting we use a resin that is mixed 1:1 with hardener. Always wear vinyl gloves when working with resin, as latex gloves can dissolve quickly when in contact with resin. Also, make sure your workspace is well ventilated.

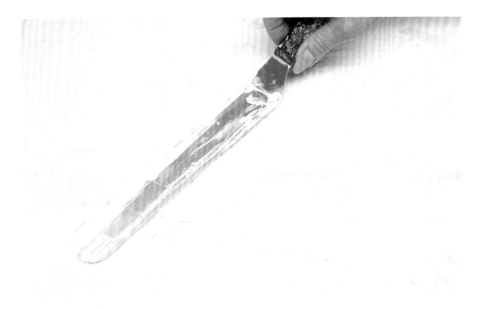

1 Pour a good amount of white acrylic primer onto your canvas. This white has a lower binder content than conventional acrylic paints and is therefore particularly suitable for mixing your own texture pastes. Add marble powder in a ratio of 1:1. To make the mixture homogeneous, carefully add a little water. Then, mix the whole thing well with a painting knife and shape it along the center axis.

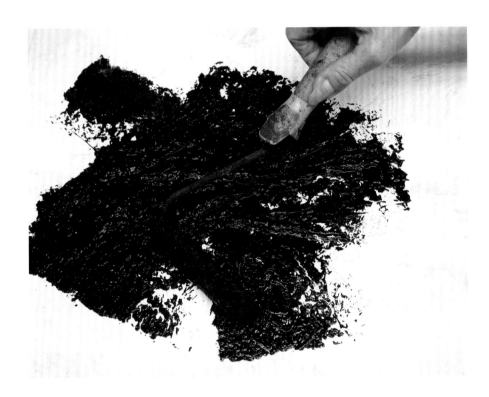

2 Carefully spread the mass up and down, leaving the center axis slightly higher. Accentuate the central axis by drawing fine lines and scratches with the sharp edge of the painting knife. After leaving your textural paste to dry thoroughly overnight, completely cover your canvas with matte black and a cotton paint roller.

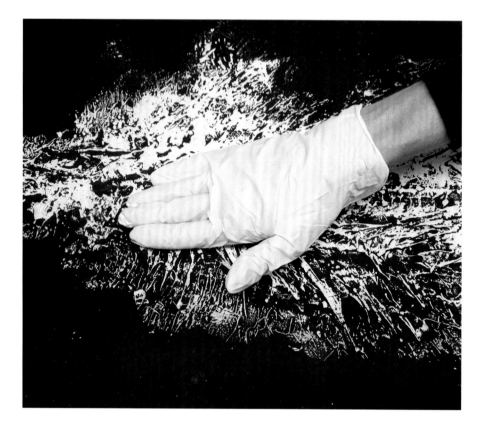

3 Now it's time to put on some gloves. Drizzle a little titanium white on the palm of your hand and add a few drops of light ochre. Mix everything lightly with the palms of your hands. Then, rub the mixture onto the canvas with the flat of your hand in a circular motion. This way, only the protruding or flattest parts of the surface will take on color, while the deepest cracks will remain visually dark. Be careful with this technique and do not use too much paint when rubbing.

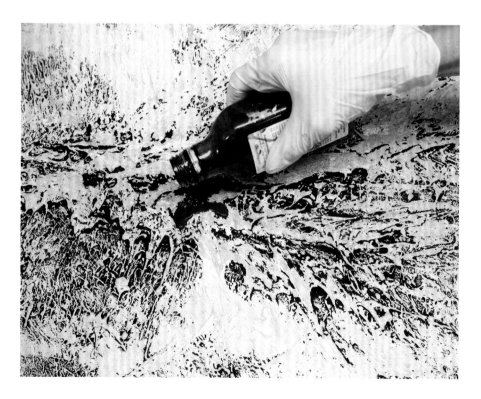

4 To bring out the subsequent brown tones, use shellac. Pour a little of it, only enough to cover the central axis of your painting. Add some acrylic ink in phthalo green and rub it all in with the palm of your hand.

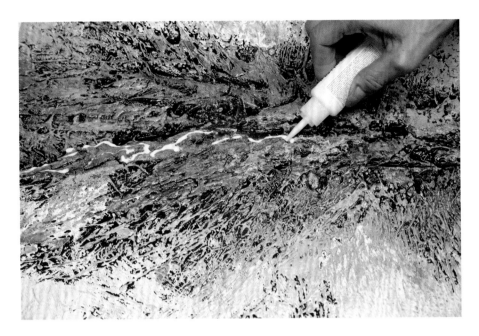

5 If you like, you can also highlight the raised parts of your painting's surface with some titanium white and phthalo green. Let everything dry well. Now, apply the guilding size to the protruding parts of the painting's surface, which should be on the center axis. Follow the manufacturer's instructions. The adhesive must dry for a good while until it is transparent and tacky.

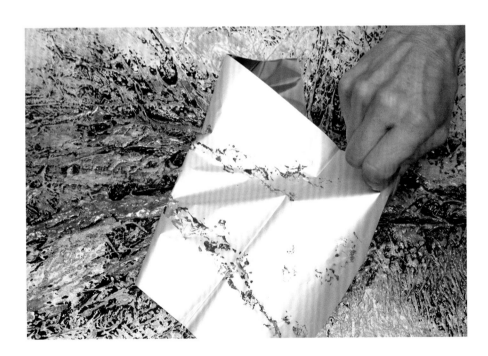

6 Next, apply your gold foil. Gold suits especially well here, but there are other metallic tones. Make sure that the matte side of the foil lies on the adhesive. Rub the foil firmly so that the gold coating detaches from the foil and bonds with the adhesive. Then, remove the foil carefully and slowly, avoiding jerky movements. Allow everything to dry thoroughly.

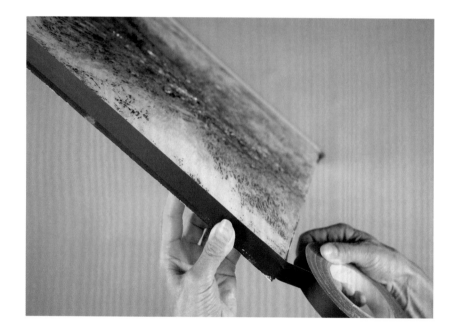

7 In the next step, wrap the edges of your canvas with cloth tape. Let the tape extend about three millimeters beyond the top edge of the canvas. This provides a border so that the liquid resin does not run over the edge during application. Mix the resin with the hardener in a mixing cup, in this case in a ratio of 1:1. Use a stirring stick for mixing. If the resin is very viscous, you can heat the mixing cup slightly with a hair dryer. This will make the resin more fluid.

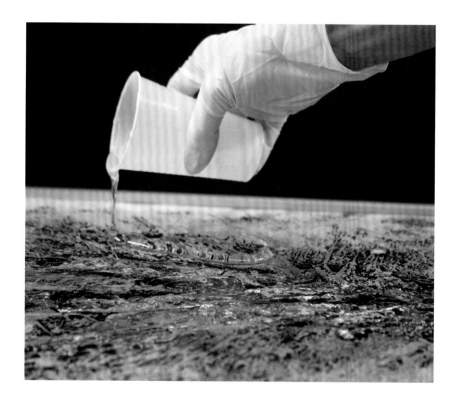

8 Apply your mixture. Make sure that the design is nicely embedded and that the protruding parts no longer stick out. You can also use a hair dryer to spread the resin mixture better. Be careful not to use too much airflow so that the resin does not spill over. If used carefully, the blow drier will cause the resin to run evenly into the smallest spaces and any air bubbles will be destroyed by the heat. Let everything dry flat for eight to twelve hours. Despite the subtle coloring, your work will appear very brilliant, as if cast in glass.

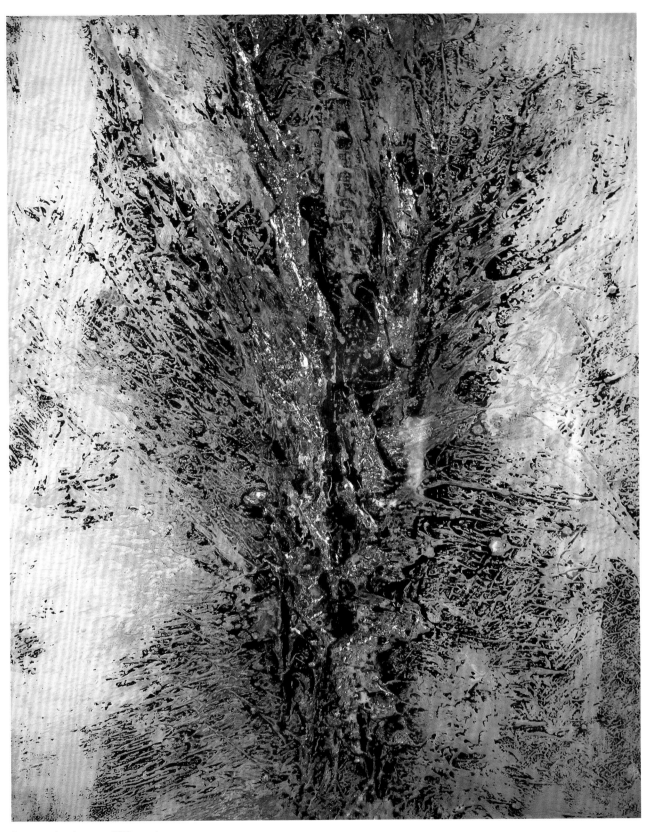

Rotate the image 90° to view

SHADOW PLAY

SIMPLE CONTRAST—AMAZING EFFECT

MATERIAL

Stretched canvas or
canvas board
10″ × 12″ (25 × 30 cm)

COLORS

Titanium white
and quinacridone
(transparent) orange

BRUSH

Synthetic hair flat
brush size 4″ (10 cm)

Black permanent
marker in size 6″
(14 cm), and a HB
pencil

The shadows in my garden have always held a special charm for me. I began to put them on canvas. Take your canvas out in the sun and after a few minutes you will discover the most interesting designs.

TECHNIQUE

This is where you place two different, contrasting acrylic colors next to each other. Use high-quality paint, two 2oz (60 ml) tubes are enough. Always start with a transparent color. The opacity of your colors is sometimes indicated by a small square on the tube. If it is not filled in, it is a highly transparent color. A half-filled square means semi-transparent and a completely black square means that the color is opaque. After drying, apply the opaque contrasting color to the shape you have already filled with transparent color.

1 First, draw the shadow in pencil on your canvas. You can choose abstract shapes. Then, trace the lines in black permanent marker.

2 Spread quinacridone (transparent) orange over the entire surface of the picture with the wide flat brush. Make your brush strokes in different directions. At the very end, blend the color evenly in one direction. Let the paint dry well.

TIP: You can use any transparent colors you like for this technique.

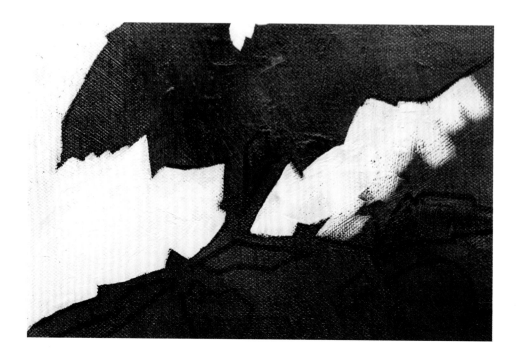

3 Apply your opaque white with the small flat brush. Use the edges of the permanent marker where it shows through the transparent layer as a guide and place your brush there. Paint all the spaces in between in this way. Work from the edge to the center.

TIP: Always draw the paint out completely so that no coarse textures remain, and the transparent color can work in layers. You can even paint beyond the edge—this looks particularly impressive.

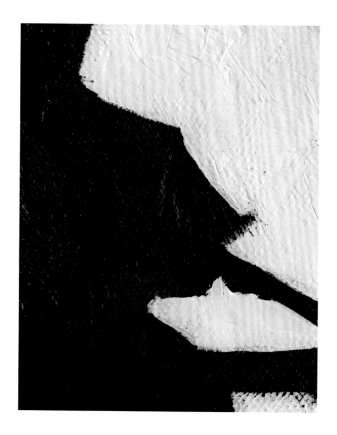

4 In the last step, color both the white and the transparent surfaces from the inside out. Now, start inside the areas and let the paint fade out as you move toward the edge. This creates lighter and darker areas that make your image glow.

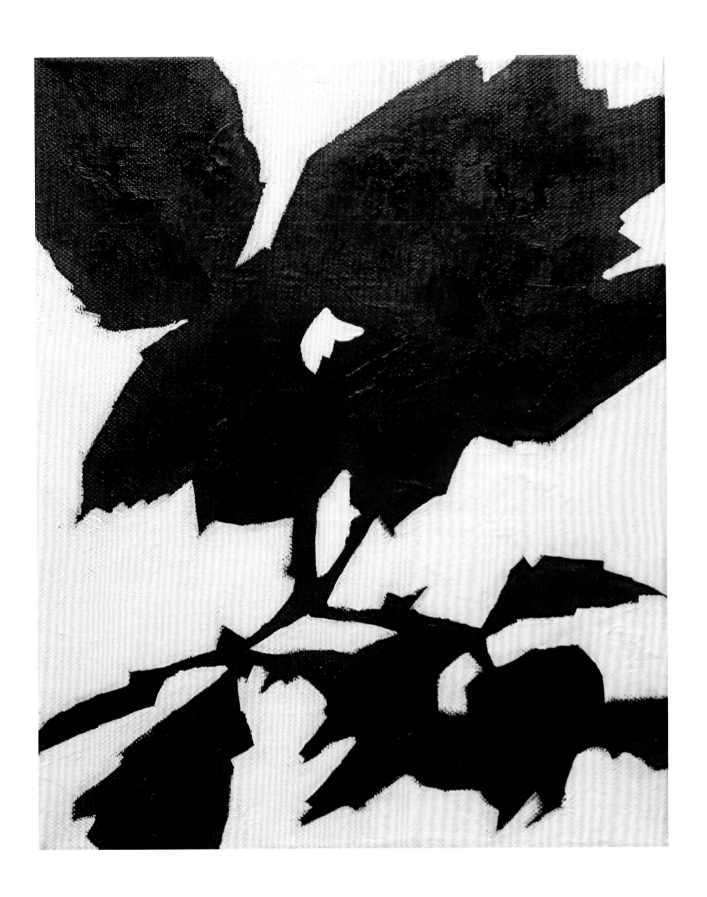

SUMMER MEADOW DREAM

DELICATE FLOWERS USING BUBBLE TECHNIQUE

MATERIAL

Stretched canvas or
canvas board
12″ × 16″ (30 × 40 cm)

COLORS

Fir green, May green,
white, quinacridone
gold (if required)

Acrylic ink in magenta,
yellow, and cerulean
blue

BRUSHES

Flat brush size 2″
(40 mm), cats tongue
brush size 10

Plastic container,
dishwashing liquid,
drinking straw, water,
and synthetic cloth

A blue sky above you, a delicate fragrance tickling your nose, buzzing and humming all around you, and bright blossoms gently swaying in the wind—the soap bubble technique creates the impression of a summer meadow. Over the course of several steps, the image emerges differently over and over.

TECHNIQUE

You can create delicate flowers using the soap bubble technique. Add a dash of dishwashing liquid to the paint and just as much water in a plastic container. The bubbles of water, detergent, and paint burst on your canvas surface and create gossamer, delicate colored prints. You can play around and experiment with different colored bubbles. You might be satisfied with the result after just a few steps. If you like, you can also continue with the printing and glazing.

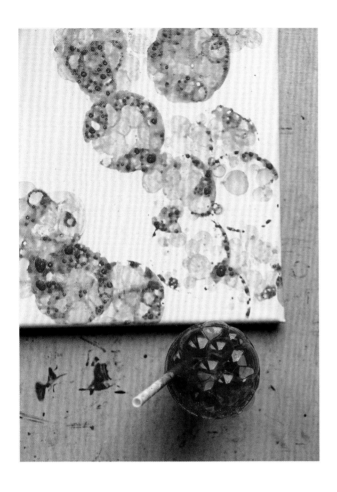

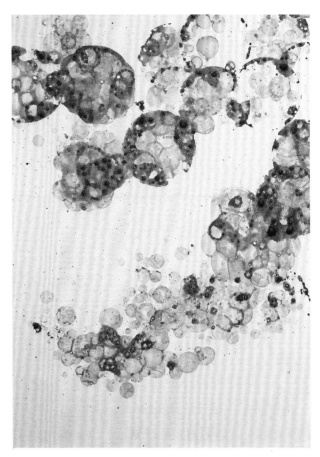

1 Add a dash of dishwashing liquid to an equal amount of water in a plastic container. Add 20 drops of magenta acrylic ink and try to create foam by blowing into the mixture with a straw. Keep adding water or dishwashing liquid until the foam bubbles are more stable and do not burst too quickly. Keep bubbling until the foam swells over the rim of the cup, then gently press your canvas onto the tower of foam.

The bursting bubbles will leave delicate impressions on your canvas. If the imprint is too faint, add a few more drops of ink. The more concentrated the bubbles are on your canvas, the larger the foam prints will be.

2 Repeat the foam bubble prints several times. Be sure to always hold your canvas very carefully against the foam so that the surface remains untouched except for where the bubbles pop.

Add some acrylic ink in yellow for the lower flower arch. Arrange the individual bubble prints into a larger, curved shape. To move the foam, use a spoon. If you are satisfied, you can finish your work here. The airy, floating shapes already appear quite decorative.

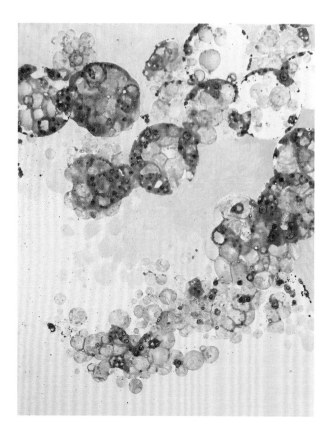

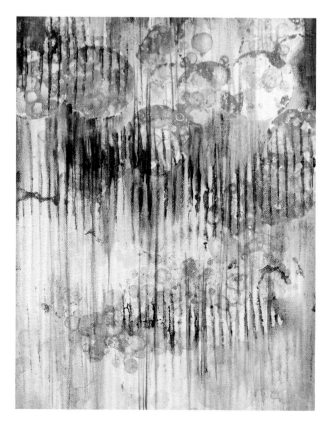

3 Paint the spaces between the soap bubble flowers with the May green color. The fresh green tone contrasts strongly with the magenta designs. Finish the layer with painted bubbles.

4 Add some blue bubble designs at the bottom of the painting. Mix water, dishwashing liquid, and cerulean blue acrylic ink. When everything is dry, you can print stem designs using a small piece of torn corrugated cardboard. To do this, paint the corrugated cardboard with pine green and place it directly on your design. Extend a few lines with the edge of the brush. Let everything dry well.

Finally, give the image its pastel quality using a glaze of mixed white. Glaze the white over the design with a wide brush and very little water, so that the colors still shine through. Use a synthetic fiber cloth to rub the blossoms that should stand out more.

TIP: It always pays to include the edges of the canvas when planning a painting. In this design, painting the edges brightly with Quinacridone gold looks very nice and makes the painting even more appealing.

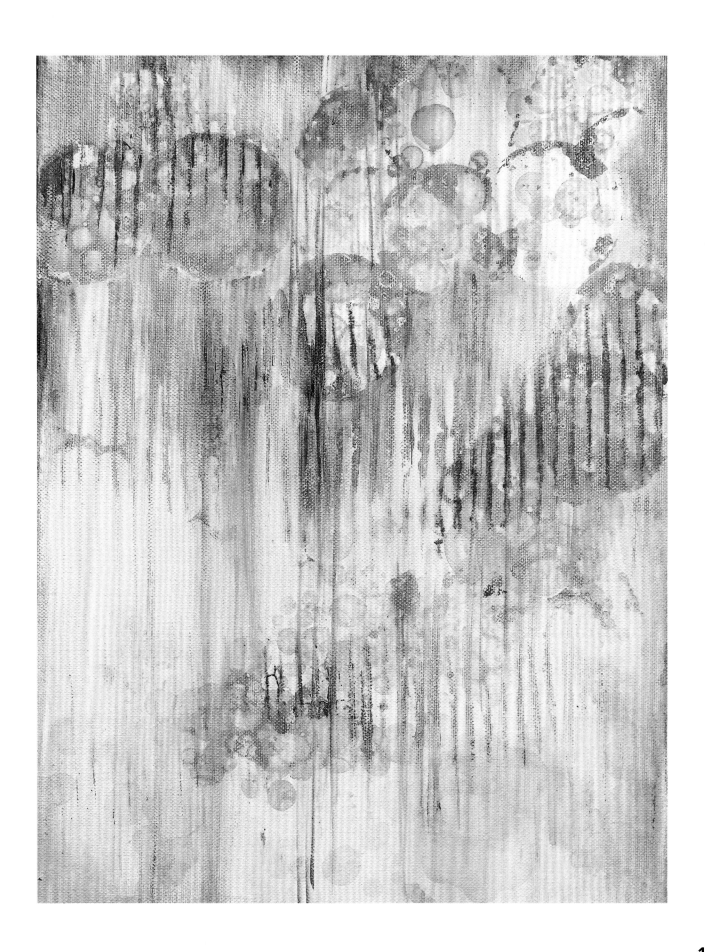

IRIS BLOSSOM

MINOR MAGIC WITH A 3D EFFECT

MATERIAL

Stretched canvas or
canvas board
16″ × 20″ (40 × 50 cm)

COLORS

Acrylic ink in cerulean
blue, yellow, and green

Heavy body paint in
violet, blue, brown, and
yellow

BRUSH

Synthetic hair flat brush
in size 1¼″ (30 mm)

Palette knife ¼″ (8 mm)
(blade length), shaving
foam, larger spatula
or baking spatula, and
paint knife

A beautiful, colorful iris set against a delicately iridescent background—can you even imagine shaving foam being involved here? No? Then it's time for some exciting, diverse print experiments. Discovering color variations and designs with shaving foam is really a lot of fun. The spatulated acrylic paint adds a textured effect to your images.

TECHNIQUE

Designing backgrounds with shaving foam isn't difficult, and it will really put you in a good mood. First, spray the shaving foam onto a plastic bucket lid or thick cardboard and smooth it out. Then, drip acrylic on it and distort it into designs. Place the surface of the canvas on the foam bed and pull it up with the foam adhering to it. After wiping off the foam, the pattern becomes visible on the canvas.

1 Spray the shaving foam at least three centimeters thick on an old bucket lid and smooth it out with a larger spatula or baking scraper. Then, drip yellow, green, and blue acrylic ink onto it and use the palette knife to blend the paint onto the foam bed.

2 Place your canvas on the foam. Then, lift it up again and spread the foam back onto the lid with the palette knife. You can repeat this process until the design on the canvas is what you want. Usually, it only takes one or two tries.

TIP: The sprayed foam can always be smoothed out and drizzled with paint again. You can try out different options on cardboard or paper.

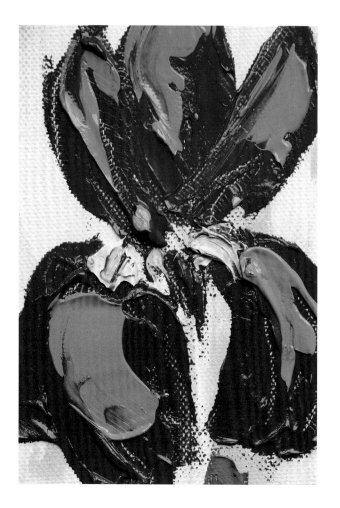

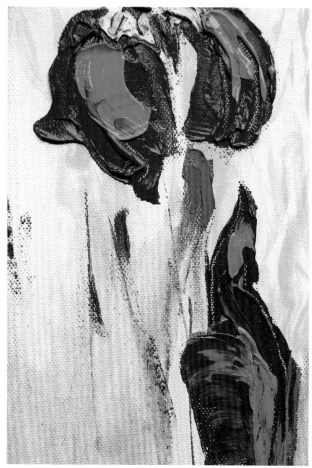

3 Using the paint knife and the heavy body colors, paint the irises onto the printed background. Start with the topmost petals and the blue paint. Follow with dabs of purple on all the blue petals. Add a little yellow for the pollen.

4 Emphasize the flower stems with ochre brown. Also, add some brown diluted with water at the bottom of the design to make the flower stand out.

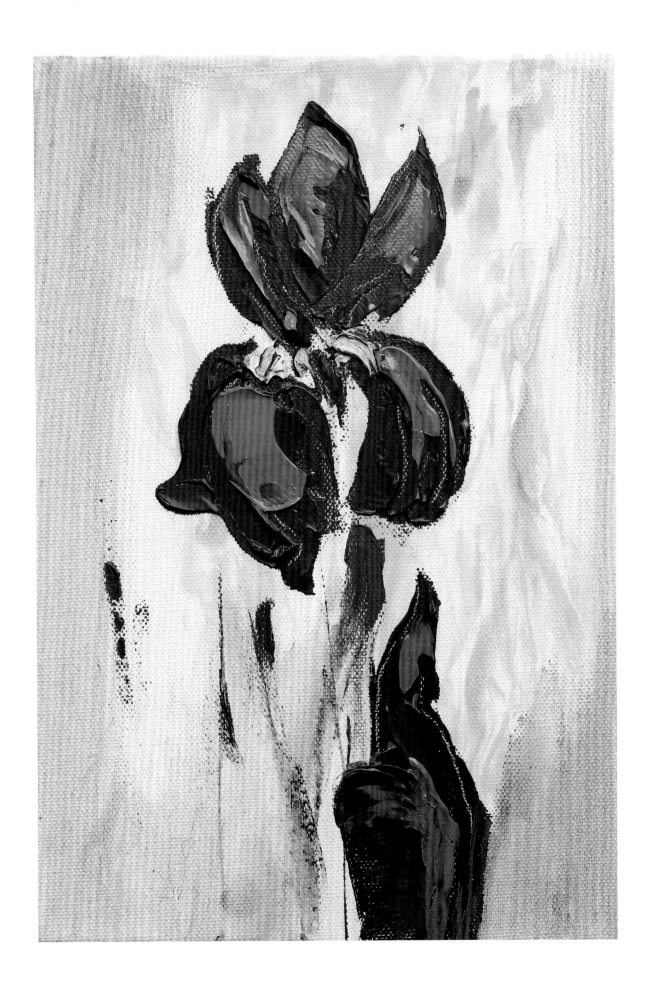

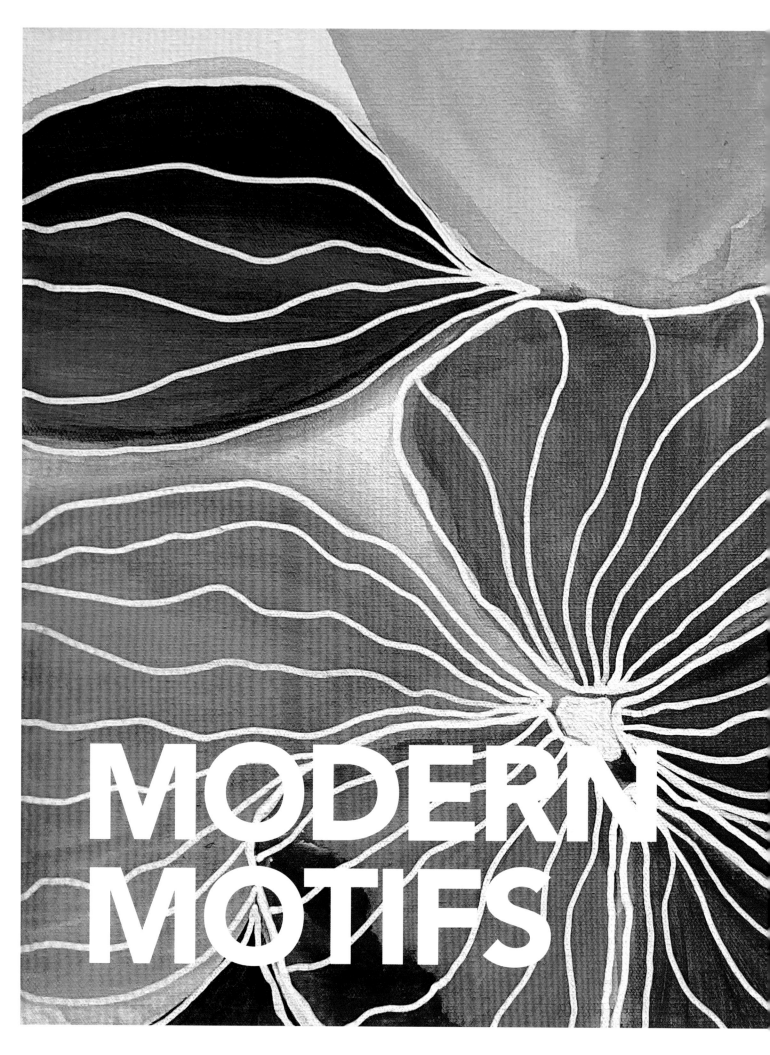

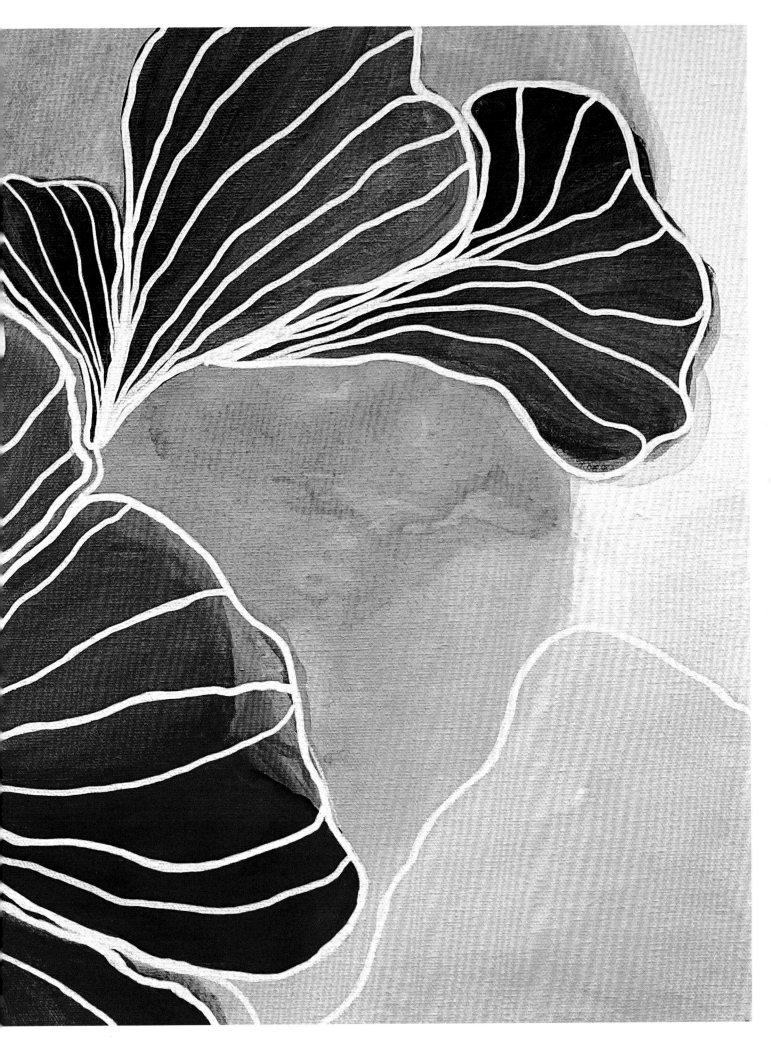

RED CLOVER

SETTING THE SCENE

MATERIAL

Stretched canvas or canvas board
16″ × 24″ (40 × 60 cm)

COLORS

Chrome oxide green, cadmium yellow, magenta, and white

BRUSHES

Wide, soft flat brushes size 6, 12, and 80 as well as round brush size 0

Fine kitchen sponge or natural sponge

Red clover lives out a rather inconspicuous existence in a large meadow, and not just because of its small size. The flowers tend to be overshadowed by the special significance the leaves have as a good luck charm in many cultures. In my picture, I have greatly magnified the whole meadow to refocus the spotlight on the flowers.

TECHNIQUE

You can use acrylic paint straight from the tube for this painting. It is also possible to mix it with a drying inhibitor (paint retarder), which can be bought from almost any art store. This gives the paint a softer consistency and allows it to be painted on like oil paint so that you create even more beautiful transitions. Both options are possible.

You'll mostly be using a *glazing* technique, which means that the paint is applied layer by layer. The blurred and clear parts are the most important aspect of this painting. The image builds layer by layer from the background up, colors becoming clearer and more radiant as you go.

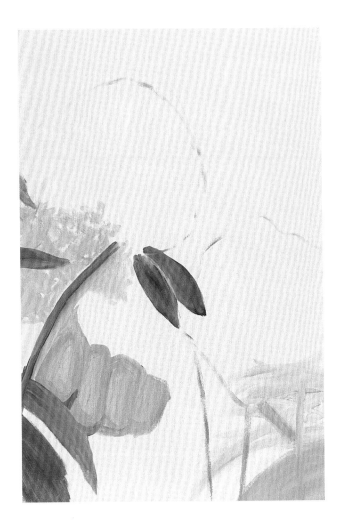

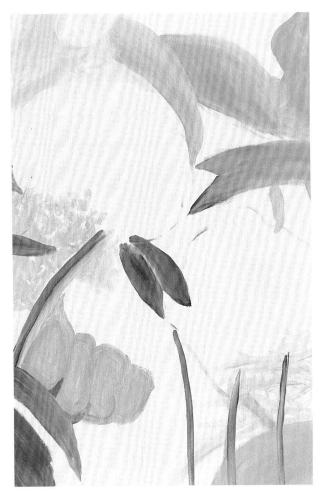

1 Using a sponge that you have previously dipped in water and wrung out, begin to apply white paint generously in crisscross patterns. Squeeze the sponge well—you don't want the paint to be too thin! Then, mix some chrome oxide green into the white and add a little yellow. Next paint rough outlines, stems, and leaves using a size 6 or 12 brush.

2 Now paint partly blurred and partly clear lines and leaves. Set the first dots of white light. This is important because the light points will make the picture shine later. In the center left and the lower right, paint crisscross with different shades of green. In the next steps, you can also paint over these areas again and again to create a blurred background.

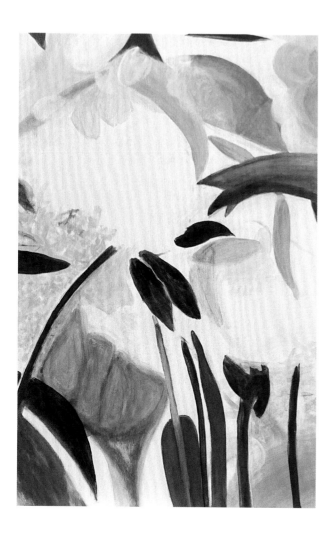

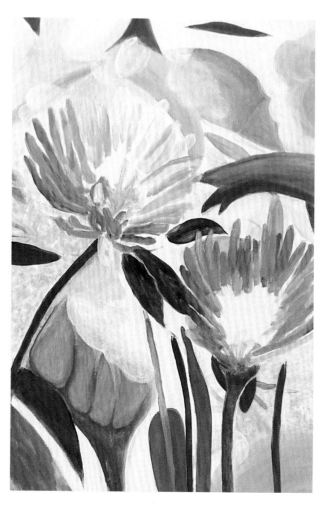

3 After the paint has dried, paint over them repeatedly. This will make the colors more vivid and give your image more depth. Be sure to include the areas you want to place the flowers later. You want to create a background with differently shaped, rather blurred, suggestions of leaves. Set more dots of light with white and paint over those that have already dried once again.

4 Next, start to shape the flowers. Mix some white with magenta and outline the petals, beginning with the outer petals. In the front part of the flower, its shape changes due to the viewer's perspective on the image. Go slowly, you can always paint over and change it later.

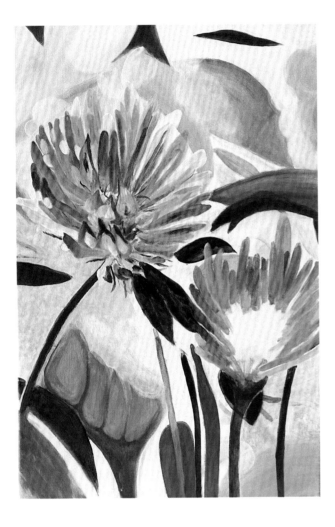

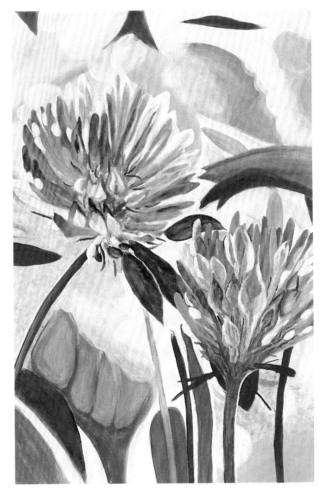

5 Now gradually make the petals more elaborate, in part by placing dark shapes on top of the light ones and vice versa. By tilting them slightly forward, the front petals will not have an elongated shape, but more of a "bulb" shape.

6 The smaller flower on the right is more visible from the side. Here the stem and the small, elongated leaflets peek out more. For the upper end of the stem, apply a light white-green mixture. When the paint has dried, you can paint the small leaves on it with something darker.

TIP: To emphasize certain elements of the picture, there are liquid acrylic paints from various manufacturers, originally developed for use with an airbrush. However, these can also be used wonderfully for acrylic paintings and gives the image a brilliant vibrance.

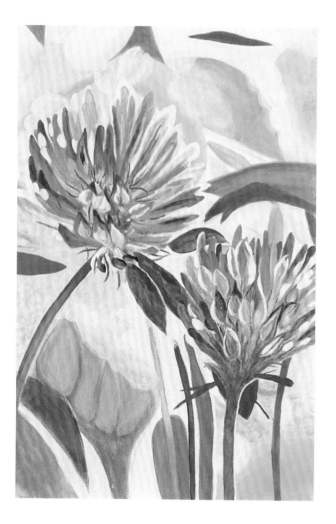

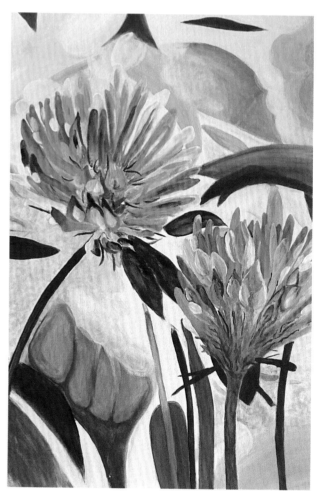

7 In this step, paint exclusively with white. It's amazing the effect you get when you accentuate the petals with white, strengthening the light spots, and adding white strokes along the stems.
Put more white petals on the greenery at the bottom of the right flower. It should only just peek through.

8 Finally, paint the petals once again. To make the background a little more diffuse, you can use the large flat brush to apply white paint diluted with water to the background. The paint should not drip from the brush—use only enough water so that you can smudge well.

TIP: During the painting process, always take a few steps back from the picture, so that you get an overall view of your work and maybe even some new ideas.

TIP: For blurring in the picture, you can also use an old painting rag instead of the brush and carefully smudge the colors with it.

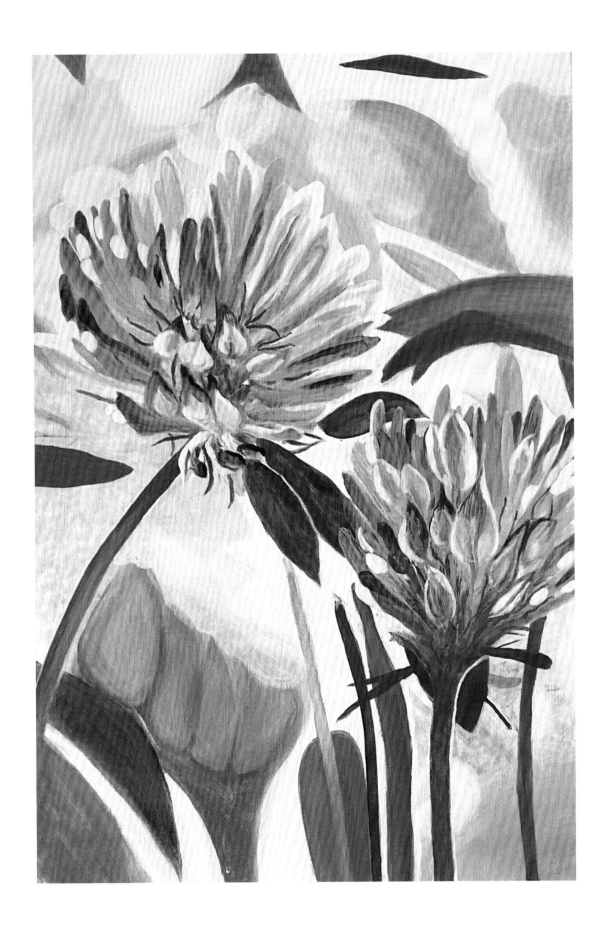

SEA OF BLOSSOMS

VIVID COLORS FOR HIGH SPIRITS

MATERIAL
Stretched canvas or canvas board 16″ × 24″ (40 × 60 cm)

COLORS
Dark green, chrome oxide green, cadmium yellow, magenta, white, and Indian yellow

BRUSHES
Bristle brush size 80, as well as soft flat brushes size 6, 12

Acrylic markers in white sizes 1/16″ to 1/8″ (1.8 to 2.5 mm)

With the pink and rose tones of the flowers' color, they resemble that of peonies, while their shape is more like oleander. There are no limits to the imagination here.

TECHNIQUE

This painting combines several techniques. At the beginning you use a wet-on-wet technique, similar to the watercolor technique. For this, you dilute your acrylic paint with a lot of water, so that the edges of the colors flow softly into each other. Later, you move on to glazing, which means that you apply the paint layer by layer on top of the dried watercolor background. After the painting has dried, you finish by outlining the petals and green leaves with a white marker. You can get acrylic markers at an artist supply store or online.

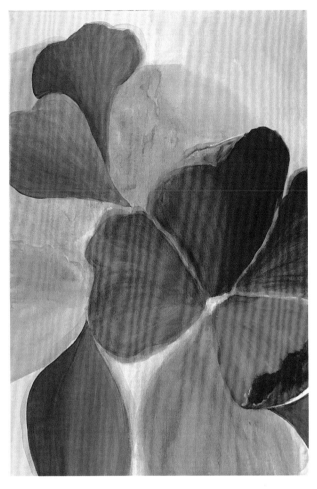

1 Begin by spraying the canvas evenly with a little water or dampening it with a brush. Mix the paints and roughly apply the shapes of flowers, leaves, and light background. This works best with a wide bristle brush. Let the first coat of paint dry. Then, begin to shape the flowers with more paint and less water.

2 Now look at the leaf shapes, then mix dark green, yellow, and chrome oxide paint with a little white and apply them to cover. Opaque means: a lot of color, hardly any water.
Apply darker areas to the petals with pure magenta in various shades. With a magenta-white mixture, on the other hand, you create brightness. As before, use very little water.

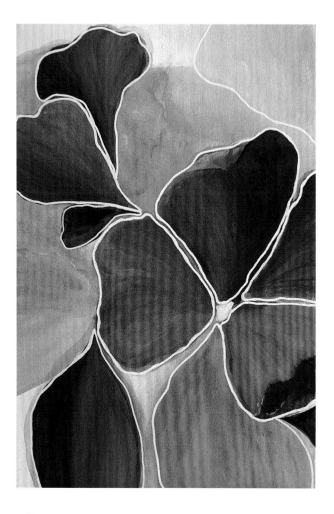

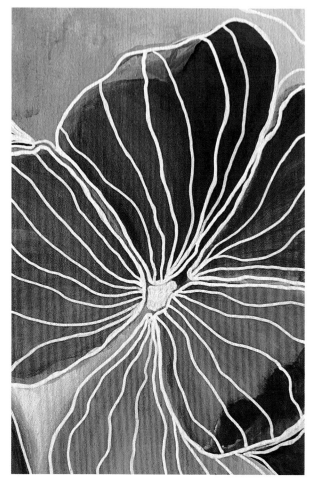

3 Next, paint over the leaves again after they have dried. Add a small leaf if you like, to round out the composition.
Now it's time to outline the flowers and leaves. It's best to test your marker beforehand on a practice sheet or an old canvas so you can get a feel for it. Start with the petals—the strokes don't have to be exact—then outline the leaves with your marker.

4 Finally, there's a fun task waiting for you: Apply the stripes inside the petals with the marker. Leave some petals free, so that the design comes into its own and the picture is not too jarring.

TIP: This technique offers unlimited possibilities in the choice of colors and shapes. The markers are available in different colors and sizes, so you can always achieve new effects through different combinations. You can also create fantastic underwater worlds in different shades of blue and turquoise.

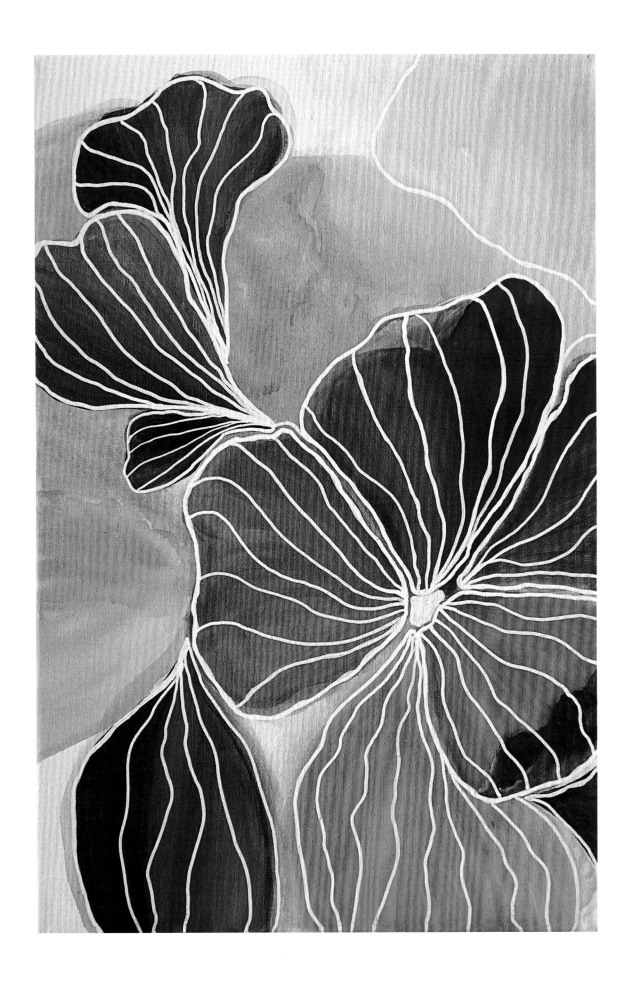

SOAP BUBBLES

THE ALLURE OF RAINBOW COLORS

MATERIAL

Stretched canvas or
canvas board
16″ × 24″ (40 × 60 cm)

COLORS

Chrome oxide
green, cadmium
yellow, light ocher,
magenta, phthalo
blue, turquoise, and
titanium white

BRUSHES

Wide soft flat brushes
size 6, 12, 80 as well
as round brush size 0

Different sized round
shapes, e.g. old
yogurt containers
or similar.

They conjure up a smile on our face and we usually associate them with good childhood memories, with lightness and fragility.
Soap bubbles—iridescent, floating, silky-looking balls that dissolve into nothingness with a pop. Glazing brings their diverse colors to the forefront wonderfully.

TECHNIQUE

With this *glazing* technique, the paint is applied in layers on top of each dried lower tier. This creates a spatial atmosphere, so the bubbles do not look like circles, but like balls. To achieve this effect, the paint is diluted with water. You can also mix a drying inhibitor into the paint. This way you will achieve soft, beautiful color gradients.

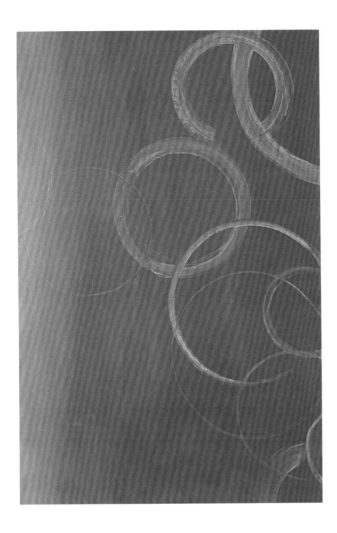

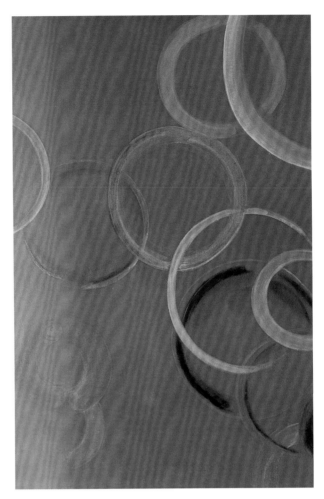

1 Apply a mixture of green and yellow to the background, preferably with a wide flat brush. Start with green at the right edge and then mix the two colors. Make sure that the color gradient is soft and gets lighter as it moves from right to left. Now, using round objects in different sizes, such as a yogurt container or a saucer, paint the shapes of the soap bubbles on in varying thicknesses using a highly diluted white. The shapes should partially overlap; this will give the image more depth later.

2 Let the paint dry somewhat and then paint parts of the bubbles with a magenta-white mixture. Use different gradations depending on which bubbles are in the background and should appear more blurred or are clearer in the foreground. Now you can use the different flat brushes to further shape the bubbles with turquoise and blue. Use the still wet consistency of the paint to smudge it. To do this, use a rather wide brush to dab the acrylic paint while it is still slightly wet, blurring first and then with fine movements.

TIP: By using a special drying inhibitor, which is mixed with the acrylic paint, the paint's consistency becomes more like that of oil paint. This will give you very nice, smooth gradients.

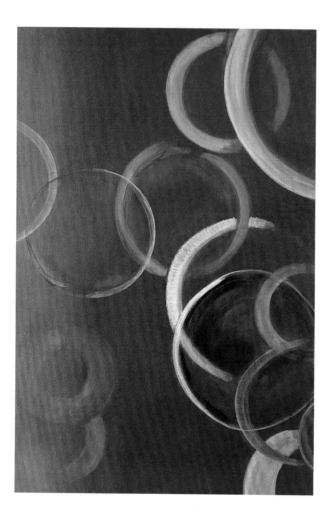
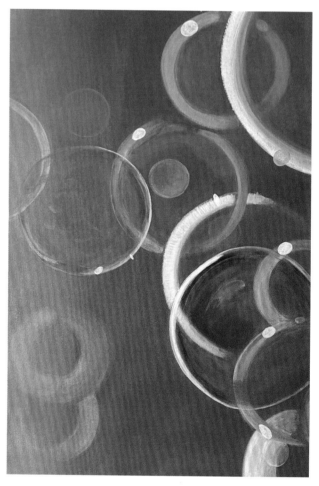

3 Apply the glaze this way layer by layer. Now yellow tones come into play as well. By adding water, the soap bubble designs in the center foreground of the painting become thin and transparent, giving them a luminous effect. You can get the blur on the two turquoise and white bubbles in the upper and lower right by making small white strokes that you then smudge.

4 In the next step, place dots of light on some of the bubbles. Paint over these white and other colored light dots again and again so that they shine beautifully. Always let the coating dry well in between. To make the two bubbles in the foreground (left in the center and right in the lower half of the image) stand out, carefully smudge the color gradients inside the bubbles once again with the different, heavily diluted colors. The repetition intensifies the effect.

Finally, set accents by adding small strokes and dots in different colors to the soap bubbles. Now you just have to decide whether the image should be more harmonious or more dynamic. Rotate the image 180 degrees and compare the result. You will be amazed at how different the effect is and how it changes.

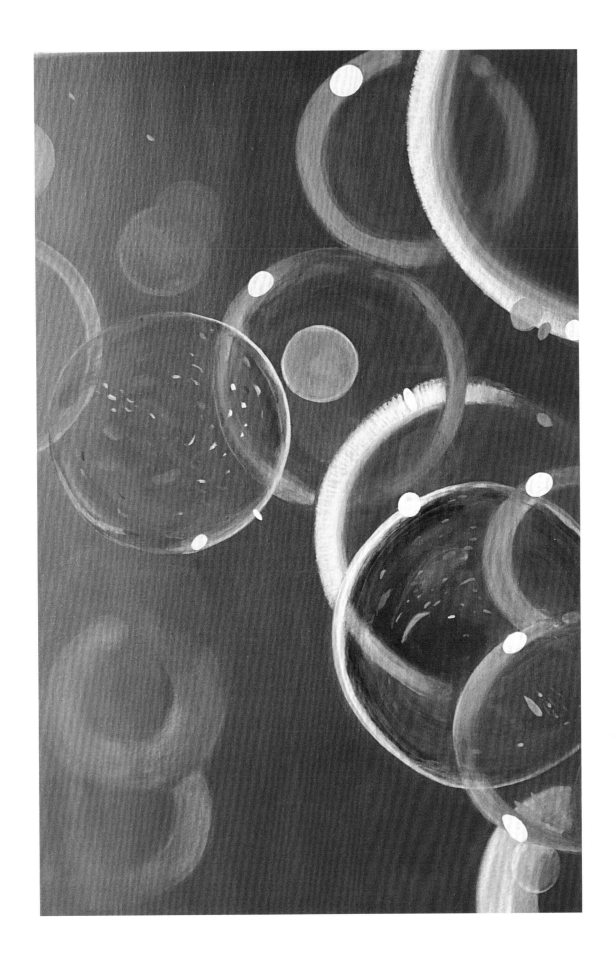

ABOUT THE AUTHORS

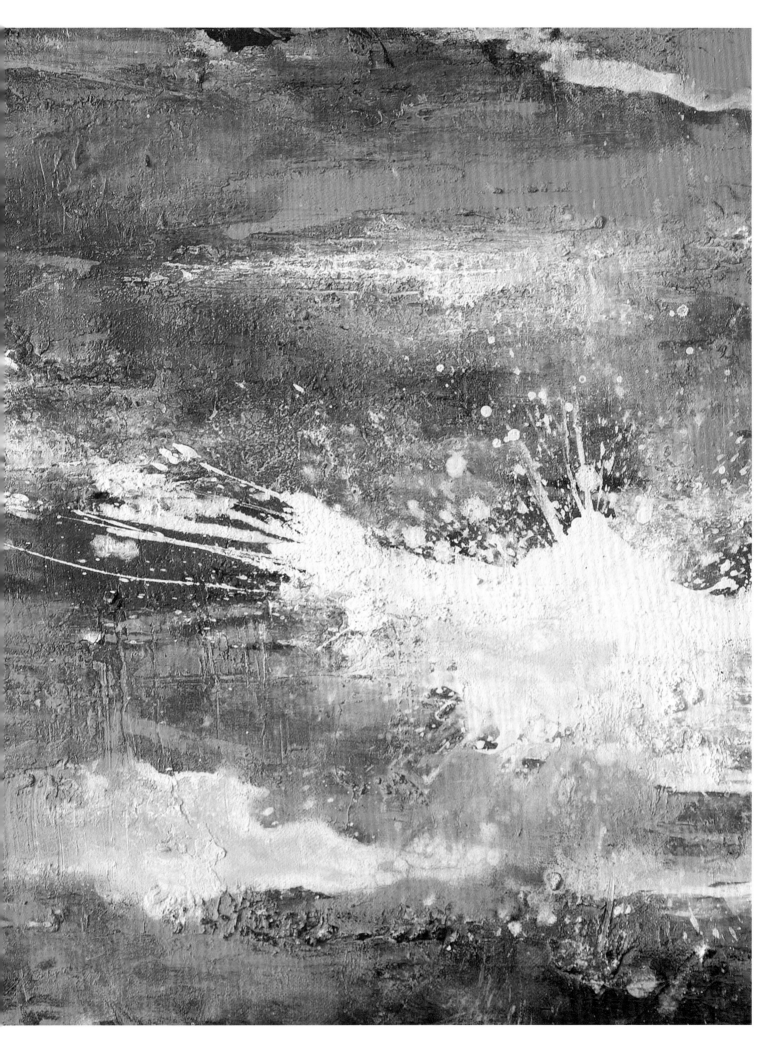

GABRIELE MALBERG

Gabriele Malberg has been intensively involved in painting since 1997. She began her training in the studio x-mal in Lüdenscheid under the guidance of Eva Hammoudo. Since then, she has shaped and refined her style of painting in many seminars and pursued further training in Munich. Her colorful paintings can be seen in exhibitions in Munich and the surrounding area. Her great passion is nature and landscape painting. Gabriele Malberg lives and works in Munich.

www.gabriele-malberg.de

SYLWIA MESCH

Sylwia Mesch lives and works in Osnabrück. She successfully completed her studies in fine arts, painting, and graphics with a diploma focusing on informal painting. Her works can be seen in many exhibitions and are in private and public collections. In 2004 she founded her own painting school where she offers courses and workshops in acrylic, watercolor, and pastel painting.
www.malschule-mesch.de

MONIKA REITER

Monika Reiter, a graduate designer, studied at the University of Applied Sciences for Design in Schwäbisch Gmünd. She then worked as a freelance product designer for various companies. Since 1987 she has worked as a course instructor for various adult education institutions, teaching her students everything they need to know about watercolor and acrylic painting along with drawing. For current information about exhibitions, courses, etc., please visit **www.reitermonika.de.**

CHRISTIN STAPFF

Christin Stapff runs the blog Mädchenkunst. She was trained as a TV editor but is now self-employed and enjoying the opportunity to combine her love of creativity with journalism. In 2015, she discovered hand lettering on Instagram—and it was love at first click. Since then, her passion has been brush lettering combined with watercolor painting.

www.maedchenkunst.de

MARTIN THOMAS

Martin Thomas has been working in illustration and painting for over 30 years, and for the last few years has focused more on acrylic painting. He mainly focuses on giving courses and events on free painting in German-speaking countries. He has also successfully conducted training courses and exhibitions of his work overseas, for example, in the U.S., England, Belgium, and Switzerland.

His goal is to pass on his professional knowledge to course participants. More important to him than the technique, however, is an enjoyment of painting, something he hopes to pass on. After working in Heidelberg, Hamburg, Dortmund, and San Diego, Martin Thomas currently lives and works in Heilbronn am Neckar.

www.martin-thomas-art.de

SYLVIA HOMBERG

Sylvia Homberg grew up near Worpswede and was influenced early on by the famous artists' colony. In 2012, she gave up her longtime job as a management assistant and from then on devoted herself entirely to painting with her partner Martin Thomas.

What followed in the intervening years were many editorial contributions and articles, as well as many exhibitions, painting courses, and fairs. Together with her partner she enjoys constantly advancing new trends, materials, and techniques.

CREATIVE
SPARK
ONLINE LEARNING

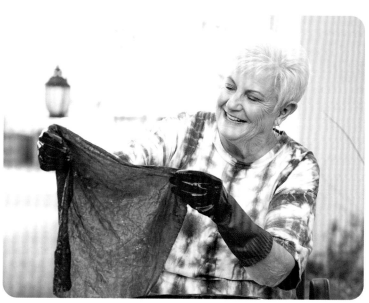
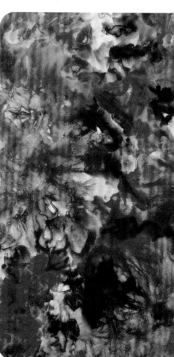

Crafty courses to become an expert maker...

From their studio to yours, Creative Spark instructors are teaching you how to create and become a master of your craft. So not only do you get a look inside their creative space, you also get to be a part of engaging courses that would typically be a one or multi-day workshop from the comfort of your home.

Creative Spark is not your one-size-fits-all online learning experience. We welcome you to be who you are, share, create, and belong.

Scan for a gift from us!